MONET'S YEARS AT GIVERNY: Beyond Impressionism

ON THE COVER:

Detail, No. 35, The Garden Path, Giverny. 1900. Lent anonymously

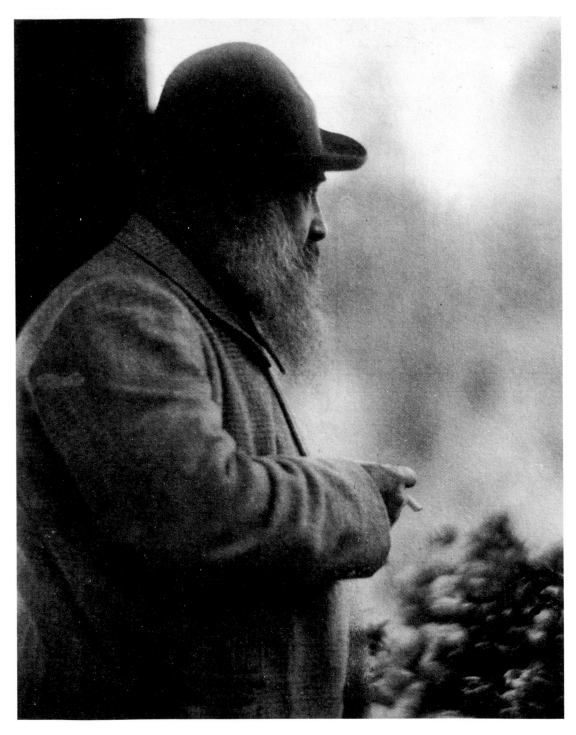

Monet looking across the water-lily pond, 1910-1914 Collection of the Musée Marmottan, Paris

MONET'S YEARS AT GIVERNY:

Beyond Impressionism

WINDWARD

Originally published by the Metropolitan Museum of Art, New York

Windward
An imprint owned by W. H. Smith and Son Limited
Registered Number: 237811 England
Trading as: WHS Distributors
 Euston Street,
 Freemen's Common,
 Aylestone Road,
 Leicester, LE2 7 SS

ISBN 0-7112-0019X

Distributed in the United States by Harry N. Abrams, Inc.

Contents

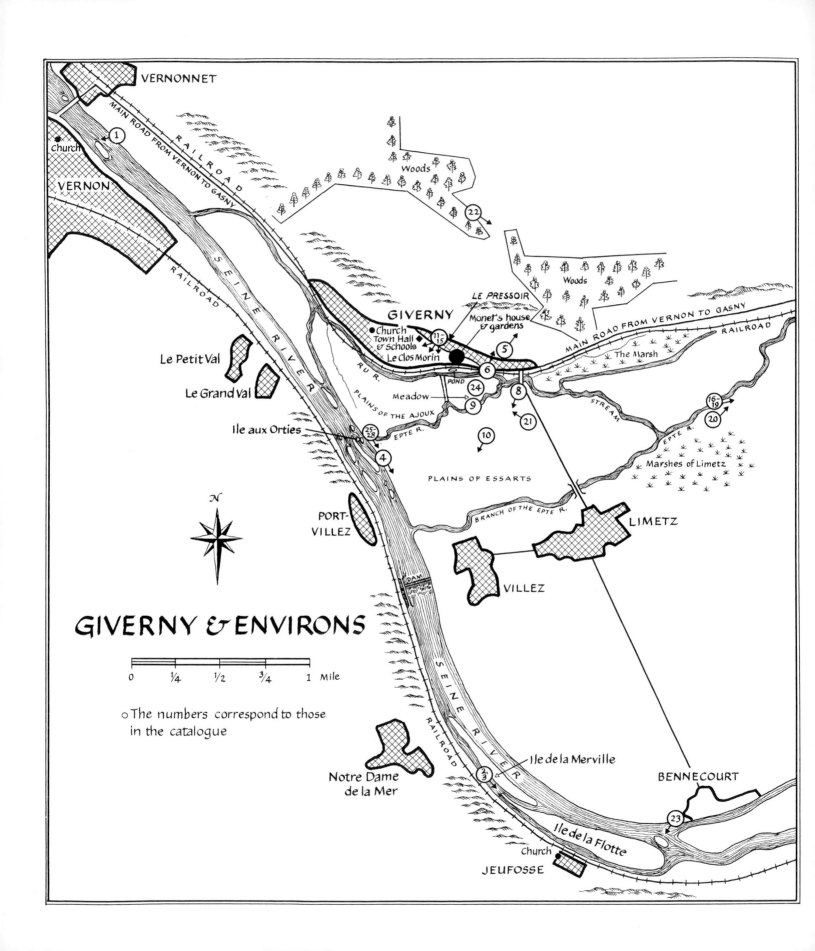

VERNONNET

RAILROAD

MAIN ROAD FROM VERNON TO GASNY

church

①

VERNON

RAILROAD

SEINE RIVER

Woods

Woods

LE PRESSOIR

Monet's house & gardens

GIVERNY

Le Petit Val

Le Grand Val

Church
Town Hall & Schools
Le Clos Morin

RU R.

⑪
⑮

⑤

⑥

MAIN ROAD FROM VERNON TO GASNY

RAILROAD

The Marsh

POND

Meadow

⑧

⑯⁻⑲

⑳

Ile aux Orties

25-28

④

EPTE R.

PLAINS OF THE AJOUX

⑨

㉔

⑩

㉑

STREAM

EPTE R.

Marshes of Limetz

N

PORT-
VILLEZ

PLAINS OF ESSARTS

BRANCH OF THE EPTE R.

LIMETZ

VILLEZ

DAM

GIVERNY & ENVIRONS

0 ¼ ½ ¾ 1 Mile

○ The numbers correspond to those
in the catalogue

SEINE RIVER

RAILROAD

Notre Dame
de la Mer

Ile de la Merville

BENNECOURT

②
③

㉓

Ile de la Flotte

Church

JEUFOSSE

Foreword

Over the past fifty years the luxuriant gardens at Monet's house in Giverny deteriorated and ran wild. Weeds choked the garden paths and flowerbeds; termites feasted on the celebrated Japanese footbridge; sludge invaded the water-lily pond. Finally the gardens were closed to visitors. Yet next spring Monet's carefully designed and lovingly cultivated gardens—which provided the greatest single source of his work for over forty years—will be reopened to the public, restored to their rampant glory. The transformation was the work of Lila Acheson Wallace, who has made miracles in a dozen realms of the world of art. In this case she worked her magic through a generous grant to the Académie des Beaux-Arts, Institut de France, the administrators of the grounds at Giverny. It is to celebrate the new flowering of the gardens and to honor the extraordinary Mrs. Wallace that the Museum has organized the exhibition *Monet's Years at Giverny: Beyond Impressionism*.

The show comprises eighty-one of the finest works painted by Claude Monet at Giverny between 1883, when he settled there, and 1926, the year of his death. The selection, made by Charles Moffett around a core of twenty-five canvases lent by the Musée Marmottan in Paris, represents the output of almost every one of Monet's years at Giverny and nearly every subject he encountered there.

Any exhibition that concentrates on Monet's Giverny cannot present the paintings in the abstract only but must consider how closely the garden itself is woven into the fabric of each work. The paintings immortalize the actual garden, which was the tour de force of the master gardener Monet, who planned every aspect of it, to be executed by a staff of professionals. There is no more happenstance in the arrangement of the flowerbeds, garden paths, lily pond, and footbridge than there is in the many striking color juxtapositions and broad brushstrokes in the late canvases that depict them. It is evident that in his

7

later years Monet's mind's eye, which knew the gardens so well, came to the aid of his failing sight. What more handsome reward could a painter of genius ask than that the beauty of his works in nature stay eternally fresh and glorious in his mind as the world around him darkened.

The cycle of the seasons is fixed; thus, in order to produce the exhibition and its catalogue to coincide with the flowering of the Giverny gardens this spring, some sacrifices had to be made—to wit, the omission of a fully researched exegesis of Monet's work at Giverny. It was decided to provide instead a full chronology and a substantial selected bibliography and to reproduce in color every painting in the show.

Actually, only when all the pictures are hung, offering the best occasion for firsthand comparisons, can a truly fresh assessment of Monet's work at Giverny be made. For this reason every opportunity will be provided for serious students of the period to view the exhibition and, by means of the subsequent publication of a compendium of essays, to reevaluate this critical period in Monet's art and its influence on the development of twentieth-century painting.

Many have contributed to the success of the exhibition. From the start it has had the support of Gérald van der Kemp, Conservateur de la Fondation Claude Monet à Giverny, Membre de l'Institut de France, Inspecteur Général des Musées, and Conservateur en Chef du Musée National de Versailles. Emmanuel Bondeville, Secrétaire Perpétuel of the Académie des Beaux-Arts, l'Institut de France, has lent his support as well, and we are grateful to him and to the members of the staff of the Musée Marmottan, Yves Brayer, Conservateur, and Claude Richebé, Archiviste paléographe.

An important role was played by Daniel Wildenstein, Membre de l'Institut, who made it possible for the Institut de France to send paintings to the United States. M. Wildenstein has contributed a lively account of the painter's life at Giverny to the present book. He also supplied information and photographs from his extensive archives and is the author of a *catalogue raisonné* on Monet, of which volumes II and III are forthcoming.

The participation of the St. Louis Art Museum was welcomed by the Metropolitan not only because of the obvious advantages of holding

the exhibition in more than one population center, but because, thanks to the efforts of director James N. Wood and several members of his board, a number of indispensable loans were secured. Alan Brimble, secretary-controller at the St. Louis museum, arranged federal indemnity for the exhibition in both cities.

For their assistance thanks are due the following: Harry Brooks, director, M. Roy Fisher, librarian, and Ay Wang Hsia of Wildenstein and Co., Inc., New York; Rodolphe Walter of the Fondation Wildenstein, Paris; William Acquavella and Rutgers Barclay of the Acquavella Gallery, New York; Ernst Beyeler of the Galerie Beyeler, Basel, and his associate Kurt Delbanco; John Szarkowski, director, and Susan Kismaric of the Department of Photography at The Museum of Modern Art; and Grace Seiberling of the National Humanities Institute of the University of Chicago.

Stephen Shore photographed the garden at Giverny, and Otto Nelson many of the loans from private collections. M. Wildenstein's text was translated by Bruni Mayor. Herbert Schmidt and Jeffrey Serwatien designed the installation at the Metropolitan. Charles Moffett extends special thanks to his assistant on the exhibition, Pamela Steele, as well as to Sir John Pope-Hennessy, James Pilgrim, Katharine Baetjer, and Mary Ann Harris. To all others at both the New York and St. Louis museums who helped in the organization and mounting of the exhibition, our thanks.

Finally, the lenders and the sponsors, who are the lifeblood of any exhibition, should crown the list of accomplishments. To the lenders, named or anonymous, go our deepest thanks. That there is an exhibition at all is a result of the enlightened generosity of two anonymous donors and a grant from the Robert Wood Johnson, Jr., Charitable Trust to the Metropolitan Museum. The St. Louis showing of this exhibition is funded by a grant from the National Endowment for the Humanities, a federal agency.

PHILIPPE DE MONTEBELLO
Acting Director,
The Metropolitan Museum of Art

Introduction

Monet's oeuvre is so extensive that its very ambition and diversity challenge our understanding of its importance. His paintings, executed over a period of nearly seventy years, weave a fabric as seamless as that of the late Water Lilies canvases. Yet this continuity was constantly enriched by innovation. The objective, early works of the precocious student of Boudin, which defined Impressionism in the 1860s, and the last paintings of the watergarden in the 1920s, with their mastery of abstraction as a means of personal expression, appear the distinct products of two separate centuries. To understand the degree to which Monet's paintings are a bridge—paralleled only by those of Cézanne—between Impressionist and twentieth-century painting, the work done at Giverny is of critical importance.

Before he moved to Giverny, Monet lived and worked at Le Havre, Sainte-Adresse, Argenteuil, Paris, Louveciennes, Vétheuil—all practically synonymous with the history of Impressionism. None of these places held his attention as did Giverny, where he settled in 1883 and where he died in 1926. While he was living there Monet traveled widely, from Normandy to the Riviera, to Rouen, London, and Venice in search of new and more challenging subjects. Yet the paintings begun in other locations—the Étretat canvases of the mid-eighties, the Rouen cathedral facades of the nineties, and the Venetian scenes of 1911–1912 —were frequently reworked and finished at home, in the controlled environment of the studio.

For the purposes of this exhibition, Giverny provides a specific focus in time and place, as it was for two-thirds of his productive life the center of Monet's existence. The eighty-one selected works have been organized by subject in roughly chronological order. They depict only scenes within a two-mile radius of Monet's home and thus within walking or boating distance. This was the landscape he came to know most intimately, in every season and under every weather condition, and its accessibility made possible the extended serial treatment that is the underlying structure for the work of the entire Giverny period.

In the late 1880s, after a period of exploration around Giverny, Monet began slowly, but by no means accidentally, to pursue new directions, to simplify his compositions and to choose subjects—fields of flowers and river views—that offered broad areas of color and tone. In time he became especially interested in reflections, and in two-dimensional imagery. The lyrical, "classically Impressionistic" compositions of the seventies gave way to a new, intuitive sense of structure, and an interest in color per se. Monet increasingly selected motifs to suit particular stylistic and formal needs; Gustave Geffroy described in 1898 the long and deliberate search for the site that was used for the Morning on the Seine series. In the same year Maurice Guillemot saw the paintings on easels in the studio, where Monet adjusted, interrelated, and completed the group, a practice he apparently began with the Haystacks series in the late 1880s. In short, Monet gradually abandoned the principal tenet of Impressionism—the accurate and quasi-scientific transcription of observed phenomena—in favor of increasing emphasis on tonal harmonies and an interest in color that depended more on the exigencies of painting than on fact.

Between 1888 and 1891 Monet produced a series of paintings of haystacks. Theme and variation had been integral parts of Monet's earlier work, but the Haystacks were the first deliberate series. Fifteen of them were shown together, separated from other paintings, in an exhibition at the Durand-Ruel Gallery in 1891. During an interview with the Dutch critic Byvanck that same year Monet stressed the importance of seeing the series as a whole. He implied that to isolate a specific moment, by painting a subject only once, was to deny one aspect of reality: the passage of time. Because one moment exists only in relation to others, an individual painting could not convey the "true and exact" effect, as Monet called it, of the series as a group. He also implied that subjective factors had begun to play an ever-greater role in his work and that he had begun to paint his experience of certain phenomena rather than the phenomena themselves. This point was dramatically borne out in 1895, when Kandinsky, failing at first to recognize the subject of one of the Haystacks paintings, realized that the incredible power of the image lay in its evocative and expressive qualities, not in its representational ones.

The concept of a unified series became increasingly important. Monet drew on the landscape around Giverny for the Haystacks (1888–1891), the Poplars (1891), and the Morning on the Seine (1897). Each

of these paintings is a metaphor for a particular mood, evoked by changes in light and atmosphere. In them Monet triumphantly fused the self-expression and subjective license of Symbolism with the profound commitment to nature that was central to Impressionism.

As the years passed, Monet's world grew more confined by his advancing age and failing vision. Finally he did not venture beyond his immediate surroundings—the garden and water-lily pool he had created on his own property. Here he painted the late series: the Japanese Footbridge (1899–1900), the Water Lilies (1903–1908, 1916–1926), and the later (1922–1923) series of the footbridge, the house seen from the garden, and the garden path. Just as Monet the painter is increasingly present in the broad handling of the painted surface so is Monet the gardener in the planted color schemes and landscaped compositions of these late works.

While the garden that he had made served as a first sketch, a springboard for the imagination, everything was subject to revision in the studio. As his world contracted his canvases grew larger, culminating in the great mural-sized waterscapes in which nature is recorded in a scale of nearly one to one. Simultaneously the point of view was elevated, leaving the observer suspended above the ambiguities of translucence and reflection, deprived of a horizon line from which to plot his location. After 1916, when the barnlike third studio was completed, Monet devoted himself to the large, decorative Water Lilies cycle that was ultimately installed in two oval rooms in the Musée de l'Orangerie, Paris. That Monet was nearly totally absorbed by a "decorative" cycle did not in any way diminish the importance of the project. Perhaps more than anything else, "decorative" suggests that he was synthesizing and abstracting form and color from nature to create a particular effect for a specific architectural setting. The image on the retina was now only a starting point, for in these vast close-ups Monet takes us through the looking glass of the pond's surface and into the shallow but infinite space of twentieth-century painting.

CHARLES S. MOFFETT
Associate Curator, Department of European Paintings
The Metropolitan Museum of Art

JAMES N. WOOD
Director
The St. Louis Art Museum

13

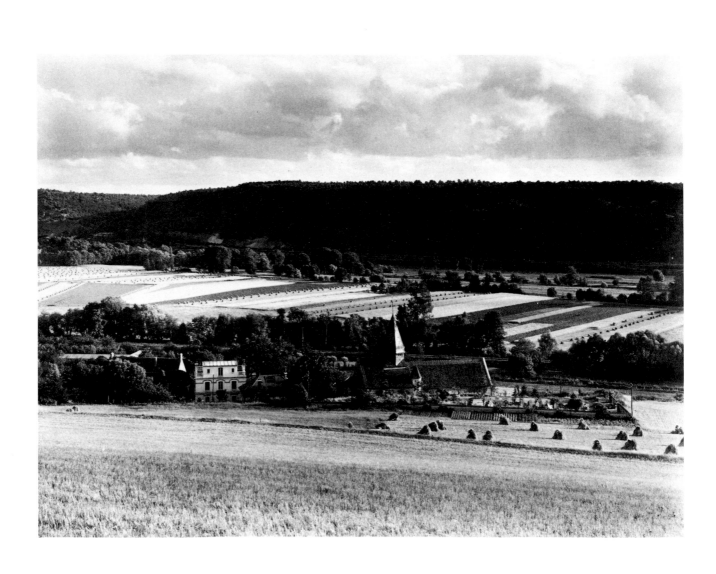

Monet's Giverny

DANIEL WILDENSTEIN

The village of Giverny rests against the hills on the east bank of the Seine at the confluence of the Epte River, about forty miles northwest of Paris. There the valley broadens, offering an extraordinary panorama. The plains of the Ajoux and the Essarts extend to the south toward the Seine, crisscrossed by ribbons of willows and poplars and by the capricious course of the Epte. On the other bank a wide arc of wooded hills—the slopes of Jeufosse, Port-Villez, and Grand Val—range from opposite Bennecourt in the southeast to Vernon in the northwest. The path of the sun follows the line of these hills so that in every season, whatever the time of day, the view from Giverny is lit from behind.

That orientation appealed to Claude Monet even before he came to Giverny. He had worked successfully at Argenteuil and Vétheuil, both of which are also on the east bank of the Seine and offer back-lit river landscapes. To paint what was reflected in the water, the movement of leaves before the light, the mist veiling the sun, a sunset or sunrise, Monet had only to follow the natural slope of the land from his house to the fields and meadows laced by water and trees. There the landscape, shimmering in the iridescent light, was constantly changing, and the hills—depending on the weather—seemed alternately purple and blue, close and far away. It was Impressionism at its purest, registered instantaneously in a natural setting that was always new and endlessly absorbing.

Monet must have foreseen all this when he looked for a house in Normandy and found, at Giverny, the property with the flowering orchard on the road from Vernon to Gasny. "Once settled, I hope to pro-

The church and graveyard at Giverny, west of Monet's house, about 1933

Collection of *Country Life* Magazine, London

15

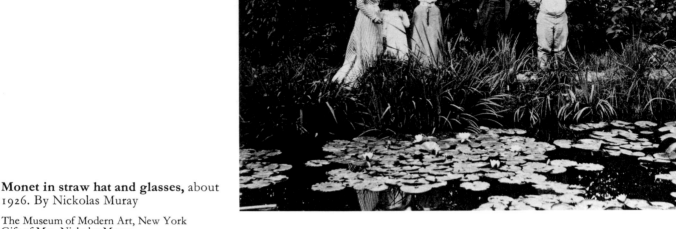

Monet (right) at the water-lily pond with Germaine Hoschedé, Lily Butler, Mrs. Joseph Durand-Ruel, and Georges Durand-Ruel, September 1900

Collection of Durand-Ruel, Paris

Monet in straw hat and glasses, about 1926. By Nickolas Muray

The Museum of Modern Art, New York
Gift of Mrs. Nickolas Muray

duce masterpieces," he wrote to Paul Durand-Ruel, his dealer, in 1883, "because I like the countryside very much."[1] Forty years later he had not changed his mind.

Another advantage at Giverny was the proximity of the small town of Vernon across the river where the children could go to school. Monet's life was always influenced by the family circle of which he was a part, and at Giverny this connection was particularly intimate. Since Vétheuil and the death of his first wife, Camille, Monet had been living with Alice, the estranged wife of his former benefactor, the collector Ernest Hoschedé. Madame Hoschedé came from an upper-middle-class family, and despite the irregular character of her relationship with Monet (until their marriage in 1892) she brought to their home an element of respectability that the people of the village could accept more easily than they might have the casual, vaguely scandalous air of an "artistic" household. Visitors from Paris, who had described the painter in his early days as a rough diamond, grew to admire his lace cuffs; Monet the bourgeois of Giverny owed much of his charm to his second wife. With affectionate authority she supervised the education not only of her own six children but of Monet's two sons, Jean (1867–1914) and Michel (1878–1966), as well. There were ten mouths to feed,

not counting the servants Monet employed even in his leanest times. Thus a certain financial urgency drove him to produce and sell paintings—a practice for which he has sometimes been reproached but which was kept within reasonable limits by his artistic conscience and growing affluence.

Psychologists will someday compare Monet and Renoir, who had so much in common in the early days at La Grenouillère, a resort on the Seine where they each painted. What motivations dictated their later development? The one was captivated by the female body in all its naked splendor, and the other almost always dwelt on the landscape, to which he subordinated his tentative figures. Monet exhorted the young American painter Lila Cabot Perry to remember that "every leaf on the tree is as important as the features of your model."[2] Yet he might not have become exclusively a landscape painter had it not been for Alice Hoschedé; his only female models were the Hoschedé girls, whom he painted with felicitous results, but never in the nude.

At the beginning of May 1883, after spending a few days at an inn east of Giverny, Monet and his family moved into a house rented from

The house from the garden path, about 1933

Collection of *Country Life* Magazine, London

Louis Joseph Singeot, a major landowner from the village, who had retired to Vernon. The two-acre property was on land known as Le Pressoir ("the cider press"), situated between the "high," or village, road and the chemin du Roy, the main road between Vernon and Gasny. The long main house faces away from the high road, which is now called rue Claude Monet. Its west wing, a barn, became the painter's living room and doubled as his first studio at Giverny. Between the front of the house and the chemin du Roy were a kitchen garden and an orchard where Monet immediately began work "so that there would be flowers to paint on rainy days."[3] Indeed, Paul Durand-Ruel commissioned panels painted with these flowers for the salon of his Paris apartment on the rue de Rome.

In good weather Monet explored his new domain. Timid at first in the unfamiliar landscape, he went straight for the element he knew best: the river, which had been the subject of so many of his landscapes in the previous ten years. Later he said, "I have painted the Seine all my life, at all hours of the day, and in every season. . . . I have never been bored with it: to me it is always different."[4] Upstream on the Port-Villez side or downriver across from Vernon the Seine was new to him, though the style of the church at Vernon (No. 1) and its reflection in the water may have reminded him of the church at Vétheuil.

The Epte River, near Giverny, with poplars and willows. Postcard, about 1900

Collection of the Musée Marmottan, Paris

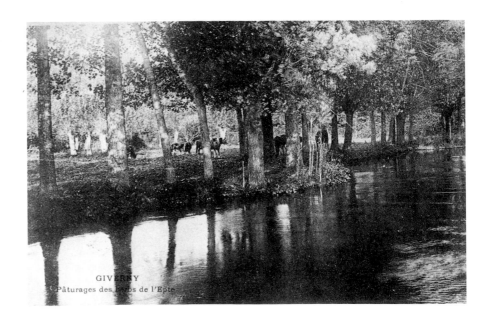

GIVERNY
Pâturages des bords de l'Epte

18

In most cases Monet painted as if viewing these subjects from the riverbank, but actually he traveled to them in his "floating studio," the largest of the four boats that he brought to Giverny from Poissy. Because the Seine was some distance away and the tiny Ru River ebbed with the tide, Monet could not bring his barge close to the house at night. Eventually he moored it at a boathouse he had built on the Ile aux Orties at the mouth of the Epte. The island was separated from the mainland by a narrow channel which was dry except at high tide.

Such arrangements were expensive, and the painter's financial situation was precarious. In a moment of dejection he confided to Durand-Ruel: "I'm afraid I've made a mistake by settling so far away. It all seems quite hopeless."[5] But another friend, the Roumanian doctor Georges de Bellio, offered him consolation:

> I hear that Giverny is lovely, and I don't doubt for a moment that you will return with a mass of paintings, all of them masterpieces. A *mass* of paintings, I tell you, because with your prodigious ability and facility, to paint is for you . . . simply to render what you see around you. Isn't it only by producing a great deal that a painter may lay claim to posterity? Don't forget that you are walking in Manet's footsteps and that in the eyes of the public you are at the head of that remarkable artistic movement in which France has set the example. Manet is dead! Long live Monet![6]

The outlook seemed immediately less depressing, and Durand-Ruel was informed: "The countryside is superb, but so far I haven't been able to take advantage of it. Moreover, I haven't painted for so long that I am going to have to ruin a few canvases before I succeed. And then it always takes a while to get to know a new landscape."[7] How often one finds this last statement in Monet's letters. He was slow to adjust and so conscientious that he was sometimes filled with self-doubt. Such doubt would have caused a weaker man to fail, but in Monet it guaranteed both quality and success.

Things at Giverny fell into place without too much difficulty. But, though he was basically even-tempered, Monet could occasionally throw terrible tantrums. The reasons were almost always the same: a failed painting, a recalcitrant motif, a change in the weather that forced him to abandon a canvas for a time. Taking it up again, he might find that a spring rain had brought a premature green to the fields or that an

early frost had made the leaves turn. The landscapes created by the snow, in which he would work "up to his neck" without complaint, were woefully short-lived. When Monet was in one of his rages, his family's only course was to wait out the storm. Sometimes his depression was so overwhelming that he roamed the fields and ended up staying at the hotel in Vernon, while at home Madame Hoschedé and the children worried that "Monet," as they called him among themselves, might not return. But he would come back, and as soon as his work went well again life would return to normal. Living so close to nature, Monet raged and smiled with the elements.

In December 1883 he traveled to the south of France with Renoir. In the early part of 1884 he went south again, alone, first to Bordighera, then to Menton. Thereafter he took painting trips almost every year until 1889 and brought back both studies to be finished in the studio (a practice to which he would not admit) and new experiences that benefited his *plein-air* work at Giverny.

As soon as he had surveyed the possibilities for pictures immediately around Giverny, he sought new fields to conquer. In 1884 he crossed the Seine to the hills on the opposite bank where the steeple of the church at Jeufosse pierced the autumn sky (Nos. 2, 3). Clearly the concept of painting in series existed in the painter's mind before he took it up systematically several years later; he painted the scene at Jeufosse —looking east-southeast—three times, with several other variations. The principle of the series developed empirically: rather than wait impatiently for the return of an effect the changing light had altered, Monet would begin work on a new canvas, then return to the first one or begin yet another as the weather dictated.

The earliest description of Monet working at Giverny was written in 1888 by the painter and part-time journalist Georges Jeanniot, who signed his "Notes on Art" simply "G. J." He was among the first visitors to Giverny. (Later all of Paris beat a path to Monet's door.) Jeanniot began his piece by dutifully reporting his host's theory of *plein-air* painting:

> Monet works only on the effect he has chosen (even if it lasts no more than ten minutes) and always works from life. He does not have what you would call a studio. He keeps his canvases in a barnlike building with a large door and a dirt floor. There he smokes his pipe and examines the

studies in their early stages, trying to analyze the causes of any defects they may have. He never retouches anything in the studio.

Having given ample proof of his loyalty, Jeanniot then proceeded to the observations he had gathered during an excursion with Monet into the meadows "scented with wild mint": "He would stop before the most dissimilar scenes, admiring each and making me aware of how splendid and unexpected nature is." Then, of Monet's working habits, he said:

> Once in front of his easel, he draws in a few lines with the charcoal and then attacks the painting directly, handling his long brushes with an astounding agility and an unerring sense of design. He paints with a full brush and uses four or five pure colors; he juxtaposes or superimposes the unmixed paints on the canvas. His landscape is swiftly set down and could, if necessary, be considered complete after only one session, a session which lasts . . . as long as the effect he is seeking lasts, an hour and often much less. He is always working on two or three canvases at once: he brings them all along and puts them on the easel as the light changes. This is his method.[8]

Monet moved from one subject to another on a single outing. He would paint on the hill overlooking his house (No. 5), in the village (No. 6), on the roads leading to nearby towns, in the fields (No. 10), along the branches of the Epte (No. 9), and on the banks of the Seine (Nos. 1–4)—often returning with only one finished canvas. But as the artist neared fifty, such forays began to take their toll. He began to concentrate on the series paintings instead of roaming the countryside. Later Monet would claim that he had experienced a moment of miraculous inspiration one day as he was painting haystacks (*meules*) near his house: the light changed and he asked his stepdaughter to fetch him another canvas. The request, several times repeated, led to the first series paintings.

Actually, as noted above, the system for the series developed over time. In any case, the Haystacks paintings did not immediately herald a basic change in Monet's method of working. His first encounter with the haystacks motif, after the harvest of 1888, did not produce works as important as his paintings of fields and flowers executed in 1890 (Nos. 21, 22). Yet it is true that in the fall of 1890 and in the following winter Monet did produce a good run of two dozen Haystacks with notable variants (Nos. 11–15). In some of these canvases the stacks are isolated,

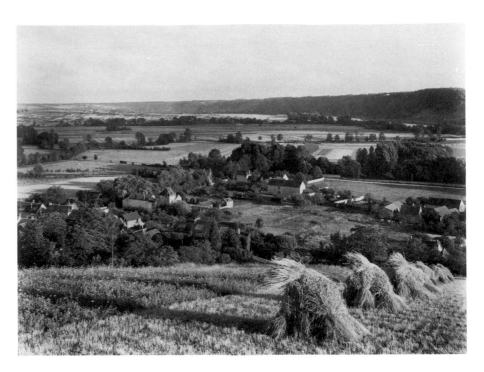

View of Giverny with the Seine in the distance, about 1933

Collection of *Country Life* Magazine, London

in others they are presented in groups, and in each they are seen from a different angle. A further experiment with the series system led to the Poplars (Nos. 16–20), which Monet painted in a marsh at Limetz, less than two miles east of Giverny. Indeed, he was so fascinated by the poplars that he paid a lumber dealer not to cut them down immediately after they had been sold.

Of course, maneuverings of this sort could be avoided if one owned the land one wished to paint. Monet's financial situation had much improved by November 1890, and he was then able to buy the house he had been renting, along with its outbuildings and gardens. It is curious that, although the family cultivated the garden carefully from the moment they moved to Giverny, Monet did not paint it for a number of years. The American painter Theodore Robinson, one of Monet's supporters, reported that greenhouses were built in 1892—evidence of Monet's increasing interest in flower subjects.

At the beginning of 1893 Monet was in Rouen painting his views of the cathedral facade. Monsieur Varenne, the director of the Rouen botanical garden, took him on a tour of the greenhouses with their prize orchids and gave him a superb begonia as well as much gardening

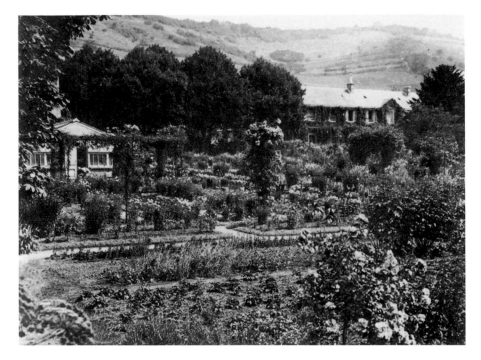

View from the garden with the green-house (left) and main house, 1924

Collection of Georges Truffaut

advice, which Monet would use later when he planted his water-lily pond.

On February 5, 1893, Monet bought a strip of land at the bottom of his property between the railroad and the Ru River, with the intention of digging a pool to be fed by the river. In nineteenth-century France, however, waterways, especially if used to power mill wheels or water cattle, could not be diverted or polluted at a landowner's whim. There was formidable local resistance to Monet's plan, which in turn caused him to explode: "Don't rent a thing, don't order any lattice, and throw the plants into the river; they will grow there. I don't want to hear another word about it. I want to paint. To hell with the natives and the engineers!"[9] In the end, however, the necessary permits were granted. Without them there would never have been a water-lily pond or the Water Lilies paintings as we know them.

Like the flower garden, the pond with the Japanese-style footbridge did not immediately become a favorite subject. Monet made three studies in 1895, one in the winter, the others during the warmer weather. But actually much of that year was spent in Norway, and in the next two years Monet often worked in Pourville on the Channel coast. This

23

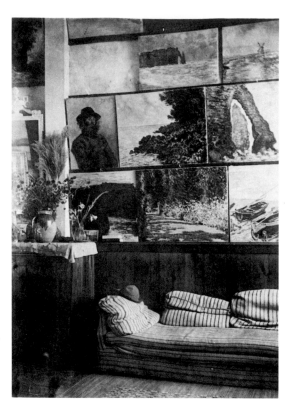

In the first studio, 1905-1906
The Museum of Modern Art, New York

does not mean he had lost interest in the Seine. One can see by comparing the Mornings on the Seine (Matinées, Nos. 25–28) to earlier paintings of the river (Nos. 1–4) that Monet had achieved a greater degree of unity within the diversity of the series.

Maurice Guillemot came to interview the master in August 1897 and saw the Mornings on the Seine in progress. "A kind of little van drawn by a white horse" collected the journalist at the railroad station in Vernon and took him to the pink house with the green shutters. The next morning at three-thirty, when dawn had barely broken, Monet appeared on the steps, "on his head a brown felt hat, picturesquely battered, the tip of his cigarette a glowing point in his great bushy beard." Followed by his guest and an assistant, Monet crossed the garden and the road, deserted at that hour, scrambled across the railroad embankment, skirted the pond—its water lilies closed—jumped the brook among the poplars and willows, and, plunging into the misty fields, came at last to the place where the Epte meets the Seine. There, as Guillemot described it, the small islands were shaded by tall trees under whose leaves creeks flowing from the smaller river formed still pools. Today the river has been dredged, and the small islands are gone, but the water, the trees, and the mist, which hovers at twilight and dawn, remain. A small boat took the three men to the floating studio anchored off the Ile aux Orties. The assistant unwrapped the canvases, and Monet set to work: "There were fourteen canvases that he had begun at the same time, a range of studies of the same motif, each one modified by the hour, the sun, and the clouds." When it became too hot, they returned to the house to take refuge "in the coolness of the studio." As if embarrassed by that term, Guillemot corrected himself at once: "salon, rather, since an artist painting from nature works only out of doors. More accurately it is a museum, there is so much to look at." The canvases were hung in three rows, "a sampling of his career, so to speak." A bell announced lunch, which was served in the dining room, where purple doors contrasted with pale yellow walls and furniture. After the meal they ascended the polished wooden staircase hung with Chéret posters. In his bedroom Monet proudly showed off his collection of paintings by friends: Boudin, Manet, Berthe Morisot, Renoir, Pissarro, Cézanne, and Degas. Then they settled under the shade of an umbrella near the pond: "On the glassy surface of the water float lilies, those extraordinary aquatic plants whose large leaves spread wide and whose

24

exotic blossoms are curiously unsettling." To this previously unpublished description Guillemot added an important revelation: "There are models for a decoration for which he has already done some studies, large panels which he showed me in the studio afterwards. . . . Imagine a round room, its walls adorned with a water landscape dotted with . . . plants. The transparent colors are sometimes green, sometimes verging on mauve. The silent, dead-calm water reflects the blossoms floating on it; the colors are fluid, with marvelous nuances, ephemeral as a dream."[10] As early as the summer of 1897, then, Monet must have conceived a large and brilliant Water Lilies series. He later presented such a series to France.

The vast panoramic paintings would have to be finished—if not entirely created—indoors, and for this Monet required a special building. To this end he had a cottage in the northwest corner of his property demolished and replaced with a large structure containing a photographer's darkroom, a garage, living- and bedrooms, and a studio with a skylight. The new, or second, studio first appears in the Giverny town records for 1899.

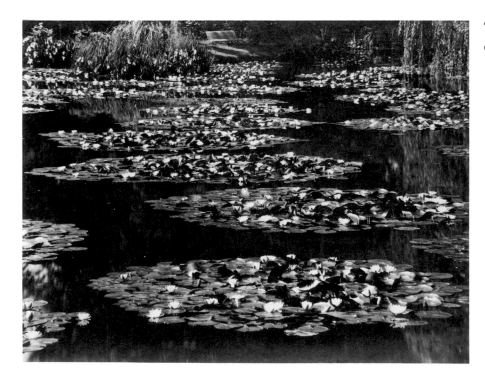

The water-lily pond, about 1933
Collection of *Country Life* Magazine, London

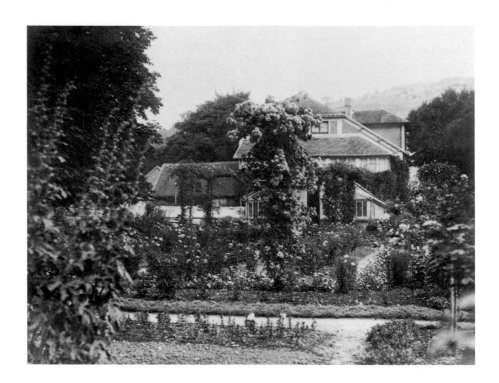

The second studio, overlooking the garden and greenhouse, 1924

Collection of Georges Truffaut

On February 6 of that year Suzanne, the prettiest of the Hoschedé girls and her stepfather's favorite model, died after a long illness: "Madame Butler, our beloved Suzanne, died last night, while her poor mother was in bed with a bad case of bronchitis which she caught the other day at Moret. One sorrow after another."[11] Alice Hoschedé-Monet never really recovered from the loss of her daughter, and in her grief she required her husband's presence as never before. His wife's needs confirmed Monet's decision to work closer to home from then on.

At sixty Monet entered the twentieth century assured of his place in the world. He was Edouard Manet's spiritual heir and had organized the purchase, by subscription, of Manet's Olympia for the national museums. He was on good terms with Émile Zola, one of France's leading writers, whom he supported in his heroic campaign on behalf of Captain Dreyfus. Two influential members of the Académie Goncourt, Gustave Geffroy and Octave Mirbeau, could be counted on for critical support. Thanks to Geffroy, Monet renewed his acquaintance with the statesman Georges Clemenceau, whom he had met many years earlier and whose career, in which success came late, paralleled Monet's own.

In 1899, a critical year in many ways for Monet, he presented Clemenceau with the painting called The Rock (Le Bloc), now in the collection of Queen Elizabeth the Queen Mother of England. Monet was not in the habit of making gifts, and the nature of the services rendered—or promised—by Clemenceau must have been remarkable.

At the time of the World's Fair of 1889 Monet had exhibited with Auguste Rodin, the greatest sculptor of his generation. Yet Monet had gradually disassociated himself from his Impressionist colleagues and consented to exhibit with them only occasionally. He was competitive and not easygoing in business; in fact no one drove a harder bargain. He was represented by several dealers at the same time: Boussod and Valadon, to whom van Gogh's brother Theo had introduced him; Georges Petit; the Bernheims; and Montaignac. And he spared none of them, not even Paul Durand-Ruel, his first supporter, who had tirelessly promoted Monet's work in France and abroad, especially in America.

Late in 1900 Monet exhibited the first pictures of the lily pond (Nos. 29, 31, 32) at Durand-Ruel's gallery. In the dozen paintings shown, dated 1899 and 1900, the water is marbled with water lilies, and the arc of the Japanese footbridge rises against a bank of greenery that partly obscures the sky. Despite the desperate monotony of the titles— The Pool of Water Lilies (Le Bassin aux nymphéas) is repeated nine times—there is a visual evolution in the work: the bridge, dead center in the first paintings, works its way to the right; the bank on the left, at first entirely absent, gains prominence. The paintings conformed to the nascent esthetics of the modern style, and the exhibition was a success, yet the critics' reproach that Monet had not varied his point of view may have prompted him to look for fresh perspectives.

In the spring of 1901 he bought a parcel of land along the Ru River to the south of his pond and soon asked permission to divert this branch of the Epte and enlarge the pond. Opposition to that sort of project had not entirely disappeared, but Monsieur Monet had become a leading citizen of Giverny. Had he not contributed 5,500 francs to the town to prevent municipal land from being developed as an industrial site? Moreover, Albert Collignon, the mayor, was a friend and never missed a chance to tout Monet as the resident genius who drew "gentlemen from Paris" to the village. A steady stream of American painters also

came to Giverny to work in the master's light if not in his shadow; Monet knew how to keep bothersome visitors at bay.

On November 13, 1901, the city council decreed that "M. Claude Monet, painter and landowner at Giverny, is authorized to divert the branch of the Epte River that crosses his land, which is situated in what is called Le Pressoir." There was a condition, however: "Concerning . . . the pond, the water entering and leaving it may not be controlled by sluices but must be free flowing." And there was a clause to reassure those living along the riverbanks: ". . . if this pond, which is for the cultivation of aquatic plants, should become a health hazard, the authorization granted to M. Monet could be withdrawn."

The work on the pond prevented Monet from painting water lilies for a time, and he was again confined to his flower garden (Nos. 34–36), where he had first painted in 1900. He would set up his easel on the path leading to the house, either between two rows of spruce trees or in the abundant flowerbeds, sometimes among the irises, sometimes under the flowering fruit trees. At the same time he was completing studies he had begun in London, his favorite European city, and at Lavacourt, near Vétheuil. The two-year period in which he did this studio work is important, as from that time on Monet no longer maintained that he worked exclusively outdoors: "Whether my cathedral views, my views of London and other canvases are painted from life or not is nobody's business and of no importance whatsoever."[12]

By 1903 the pond was again full of water lilies and Monet could make a fresh start. Abandoning the Japanese footbridge, he concentrated on the pool, where the lilies floated like so many flowering rafts. The shore, reduced in most paintings to a narrow strip (No. 38), disappeared altogether in some paintings (No. 37), as did the sky, though it is reflected in its every nuance in the water. In the canvases of 1904 the water looks extraordinarily deep (No. 39), but the paintings of succeeding years emphasize its surface quality (Nos. 40, 42–44).

Monet was now commanding such advantageous prices for his early work that he did not have to sell a single painting in 1903 and could devote himself to his water lilies without interruption. Meanwhile the Paris newspapers were sending him their "artistic" critics, as they were then called. In 1904 Maurice Kahn in *Le Temps*, the major evening paper, enthusiastically described Monet's garden. A year later, in *L'Art et les Artistes*, Louis Vauxcelles recounted an afternoon he spent with

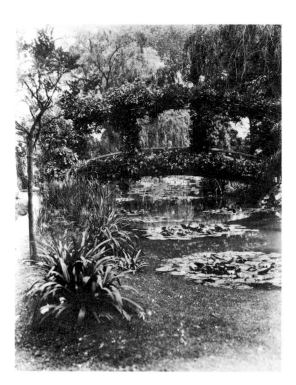

View from the west toward the Japanese footbridge, about 1926. By Nickolas Muray

The Museum of Modern Art, New York
Gift of Mrs. Nickolas Muray

28

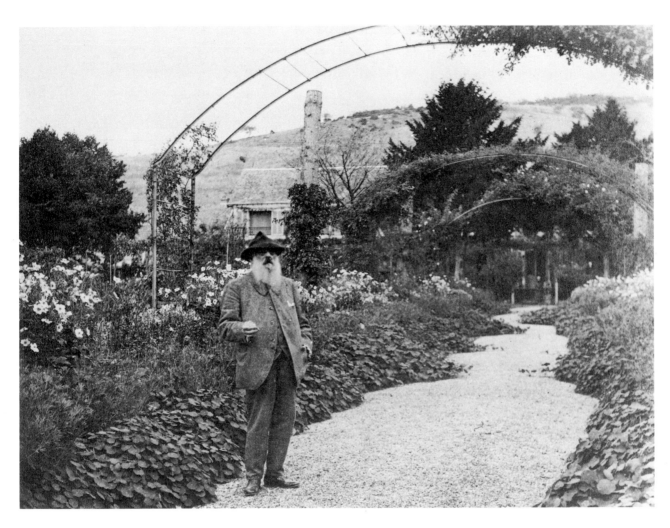

**Monet on the path leading to the
house,** about 1923

Collection of the Musée Marmottan, Paris

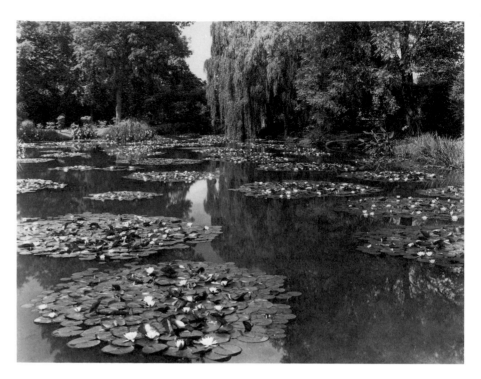

The full length of the water-lily pond, looking west toward the Japanese footbridge, about 1933

Collection of *Country Life* Magazine, London

Monet. Among the photographs that illustrated the Vauxcelles article was one of the Japanese bridge. During the enlargement of the pond it had been equipped with a trellis designed to bear climbing plants—wisteria, as it later turned out. When Vauxcelles arrived at Giverny, accompanied by the German painter Felix Borchardt, he found Monet dressed like a gentleman farmer in "a suit of beige checked homespun, a blue silk pleated shirt, a tawny velvet hat, and reddish leather boots." After a short visit in the studio-salon Monet quickly led his guests to the pond, "because the water lilies close before five o'clock." The pool was surrounded by poplars and willows, as well as an abundance of gladioli, irises, rhododendrons, and rare species of lilies. On the water's surface, the leaves of the water lilies were "spread flat, their greenness the frame for the yellow, blue, mauve or rose corollas of these beautiful aquatic flowers." More water lilies were found in the other studio, this time in series, on canvas, captured "at every hour of the day, in the lily-white light of early morning, in the bronze haze of noon, in the violet shadows of late afternoon." The Women in the Garden (Femmes au jardin) were enthroned on the wall as well, awaiting their moment.

30

Guests and host settled on a huge divan of cream-colored velvet and, through clouds of cigarette smoke, Monet talked about his life. He aimed a few salvoes at the academic painters who had once rejected him and reproached some of the "young *indépendants*" for plagiarizing their elders while avoiding them. Vuillard was credited with "a very good eye," and Maurice Denis was called "a very nice talent, and so astute," but Gauguin was the object of a broadside: "I don't understand him. . . . I have never taken him seriously anyway. And don't mention his name in Cézanne's presence." Monet thought Cézanne "one of today's masters," a statement the magazine felt obliged to footnote, saying that "esthetic judgments bind only those who make them." Vauxcelles provided a number of useful details concerning Monet's method of work: the easels were lined up in a row so that he could catch the changes in the light, and painstaking last touches were applied to certain paintings that appear to have been dashed off "vigorously in one afternoon." Monet was unapproachable when at work, but he could also spend days on end without picking up a brush. That lovely summer day was one of them, and when it was over, he accompanied his visitors to the gate "with all the graciousness of a nobleman."[13]

Monet could never be accused of excessive self-confidence. Despite Paul Durand-Ruel's entreaties, he resisted exhibiting his latest works. He burned some of them and considered the rest "really not good enough to bother the public with. . . ."[14] At last, in May 1909, *le Tout-Paris* were given their chance to honor the Water Lilies. The exhibition, at Durand-Ruel's gallery, provoked a torrent of critical attention. To quote from a short notice by Jean-Louis Vaudoyer:

> None of the earlier series . . . can, in our opinion, compare with these fabulous *Water Landscapes*, which are holding spring captive in the Durand-Ruel Gallery. Water that is pale blue and dark blue, water like liquid gold, treacherous green water reflects the sky and the banks of the pond and among the reflections pale water lilies and bright water lilies open and flourish. Here, more than ever before, painting approaches music and poetry. There is in these paintings an inner beauty, refined and pervasive; the beauty of a play and of a concert, a beauty that is both plastic and ideal.[15]

It would be difficult to express more succinctly the harmony between the painter and his time, a *belle époque* as elegant and fragile as the ephemeral flowers that were its true reflection.

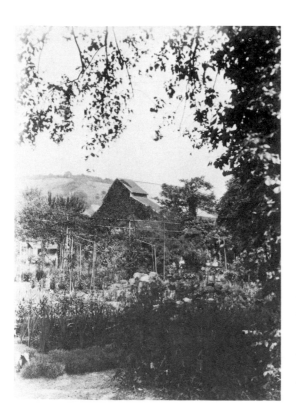

The third studio, seen from the garden, about 1926. By Nickolas Muray

The Museum of Modern Art, New York
Gift of Mrs. Nickolas Muray

During the course of the exhibition Roger Marx, in *La Gazette des Beaux-Arts*, drew a brilliant portrait of Monet in the form of an imaginary dialogue in which the painter mentioned his earlier "temptation" to use the Water Lilies to decorate a salon.[16] The idea must have still preoccupied Monet when two calamitous events followed close upon each other: on May 19, 1911, Alice Monet died, leaving a great emptiness in the artist's house; soon afterward Monet began to have such trouble seeing that he feared he was going blind. In July 1912 a specialist in Paris discovered a cataract that was not yet ready to be operated on and prescribed a treatment that would retard its growth. Delighted with this reprieve, Monet tried his hand at new subjects, such as the Flowering Arches (Arceaux Fleuris) painted in 1913 (No. 45) and also determined to carry out his great project, the late Water Lilies (Décorations). His last qualms gave way in the face of Georges Clemenceau's encouragement: "You can still do it, so do it!"[17]

Not allowing himself to be shaken by the death of his eldest son, Jean, in February 1914 or by the outbreak of the war, Monet had plans drawn for a third studio, a large building (76 by 39 by 49 feet) to be erected in the northeast corner of his property. By August 1915 the construction was well advanced, but Monet was horrified by the ugliness of the building. In the spring of 1916 he began work on the Décorations. He installed rolling easels big enough to hold canvases six feet tall and twelve feet wide. It would not have been easy to transport them to the pond, and Monet must have used studies, sketches, and perhaps even photographs. As he undertook this monumental work the artist was seventy-five years old, and the circle was complete: Monet, who in his youth had painted large canvases for the Salon, returned at the end of his life to a similar format, except that he no longer painted figures, but rather reflections in the water and the water lilies in bloom. Another innovation was the unity of the series, which was "vast as night and clarity," as in a verse by Baudelaire.[18] His name, along with those of Mallarmé and Debussy, was to become associated with Monet's.

To preserve this unity in the Décorations Monet decided against using certain paintings which, to judge from their size, had originally been intended for the series, and certain subjects, such as the wisteria (Nos. 72, 73), "the first garlands of the frieze of flowers," which was

32

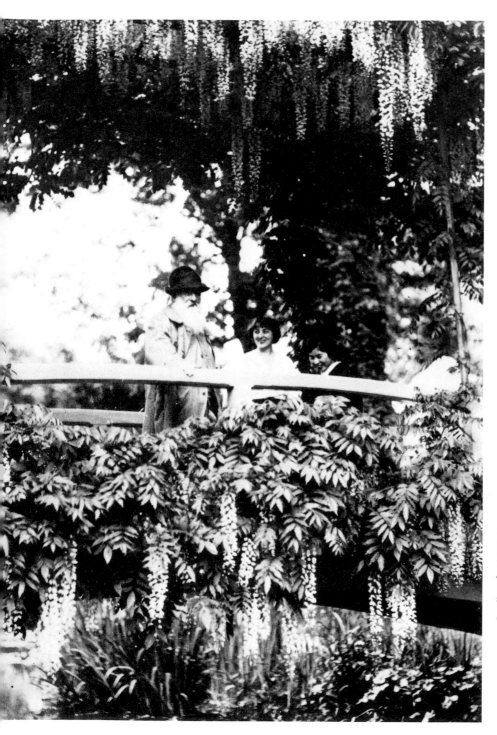

Monet, Lily Butler, and Mme. Kuroki (wife of a Japanese collector of Impressionist paintings) on the Japanese footbridge with wisteria in bloom. Blanche Hoschedé-Monet is at right. June 1921

Collection of the Musée Marmottan, Paris

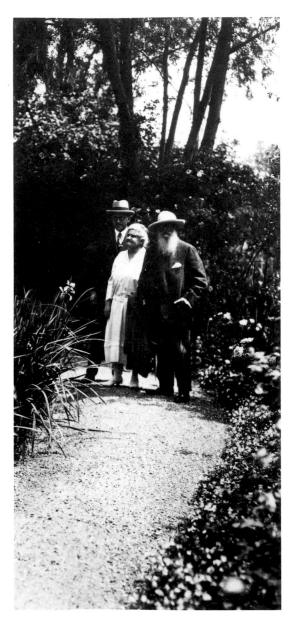

Monet, Blanche Hoschedé-Monet, and a friend on the path beside the water-lily pond, about 1926. By Nickolas Muray

to have crowned the whole scheme. This information was revealed by the duc de Trévise, who visited Giverny in 1920. Monet pushed the heavy easels around his guest, enclosing him within the "fabulous walls . . . of the enchanted pool." When asked where the Décorations were to be placed, Monet declared: "I will bequeath the four best series to France, which will do nothing with them."[19]

During the interminable bargaining that ensued, the French government agreed to buy Monet's Women in the Garden (Femmes au jardin) for 200,000 francs. Finally, on April 12, 1922, in a lawyer's study in Vernon, Monet signed the papers donating the Décorations to the state. Paul Léon, the director of the Beaux-Arts, had not seen the end of his problems, however. The painter was punctilious about every question relating to the preparation of the Orangerie of the Tuileries for the installation of his work. At the same time he continually retouched the panels he considered incomplete, despite recurring eye trouble.

On September 7 Dr. Coutela, Monet's Paris eye doctor, diagnosed "a degenerative cataract," which had reduced Monet's vision "to one-tenth in the left eye and to the perception of light with good projection in the right eye."[20] This did not prevent Monet from telling Étienne Clémentel two months later: "I have taken up my brushes again, and I am working with a little difficulty, of course, but I am working, and I intend to complete my Décorations by the appointed date."[21]

The first operation, on the right eye, which was the more severely affected, took place in January 1923. "Hello, Dr. Coutela, I am doing very well," says a short note, scrawled by Monet in his hospital room at Neuilly, where the operation had been performed.[22] In mid-February, before returning to Giverny, Monet was well enough to propose to Clemenceau that they visit the Orangerie. Paul Léon was summoned as well and was urged to bring the architect. The old man hadn't changed; he was as demanding of others as he was of himself.

Fortunately, Blanche Hoschedé-Monet, the widow of his son Jean and a painter herself, served Monet untiringly, and Dr. Rebière, in nearby Bonnières, watched over his health. And then too the "Tiger" (Clemenceau) lavished encouragement on Monet in his typically outspoken way: "How can I seriously consider the question of whether you are blind as Homer was blind or simply mad like our doctors?"[23] Dr. Coutela performed a second operation on the right eye at Giverny in July 1923. Although not as serious as the first, it was painful surgery

34

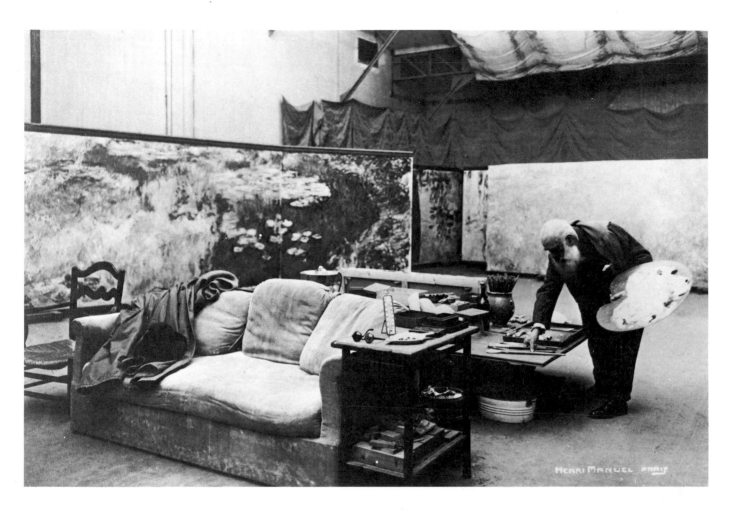

Monet in his third studio, surrounded by panels of his large Water Lilies series, 1920s. By Henri Manuel

Collection of the Musée Marmottan, Paris

all the same. During an examination in September the eminent ophthalmologist noted that visual acuity was adequate and distortion only slight; but "Monet is most upset by the colors: he sees everything too yellow" due to a rather rare phenomenon known as xanthopsia.[24] Otherwise, he could see his palette and the brushstrokes well enough but could no longer check his work by standing back ten or fifteen feet as he was used to doing. This jeopardized the Décorations, as Clemenceau realized, yet he urged his friend to continue, saying, ". . . God himself would tell you that you cannot always create miracles."[25] Later he wrote, "An American publisher has offered me a million francs for my memoirs. I have accepted on condition that you write them. At least while you are doing that I could do your painting."[26]

35

Monet beside the water-lily pond,
1926. By Nickolas Muray

The Museum of Modern Art, New York
Gift of Mrs. Nickolas Muray

Next Monet was bullying his friend into sending him quantities of blue paint. No longer afflicted with xanthopsia, he now saw everything tinged with blue. Indeed, Professor Jacques Mawas, whom the painter André Barbier had brought to Giverny in the summer of 1924, noticed that blue seemed to dominate in the painter's work. Monet complained, "It's disgusting, I see everything in blue!" The professor countered, "How do you know you are painting in blue?" The patient replied, "By the tubes of paint I choose."[27] Mawas prescribed two pairs of glasses from Meyrowitz, which did not immediately correct the condition. Monet's disappointment was such that, about January 1, 1925, he threatened to write to Paul Léon, to tell him that he would not deliver the Décorations. Clemenceau wouldn't hear of it: "My poor friend, I don't care how old, how exhausted you are, and whether you are an artist or not. You have no right to break your word of honor, especially when it was given to France."[28] And, to register his disapproval, he refused to go to Giverny.

The Zeiss lenses Mawas had ordered to replace Monet's original ones finally brought the expected improvement. "Since your last visit," he wrote to Barbier on July 17, 1925, "my vision has improved tremendously. I am working harder than ever, I am pleased with what I do, and if the new glasses are better still I would like to live to be a hundred."[29] Clemenceau echoed this optimism: "While you have such good fortune, hold on to it."[30] As before, the painter set upon his motifs with ever-renewed pleasure, and, as before, he complained to Geffroy that he had no time to complete the many canvases he had begun. He no longer refused to give the Décorations to France, however, and he planned to resume work on them in the fall.

Early in the spring of 1926 Gustave Geffroy died. Clemenceau, ill himself, was greatly affected by the loss of his old collaborator. The painter Jacques-Émile Blanche, traveling through Giverny, saw Monet through the fence of the property, and mentioned that he still looked robust. Dr. Coutela, asked early in June to take action by Dr. Rebière, informed Clemenceau that he was worried about his patient's health. On the 8th Vuillard, Roussel, and Jacques Salomon came for a lunch at which Monet plainly drank more than he ate. On the 14th René Gimpel visited Monet and bought two pictures. Monet still had difficulty eating and thought it was the result of the tracheitis that had afflicted him during the winter. Yet he received Gimpel again on July 17. By now

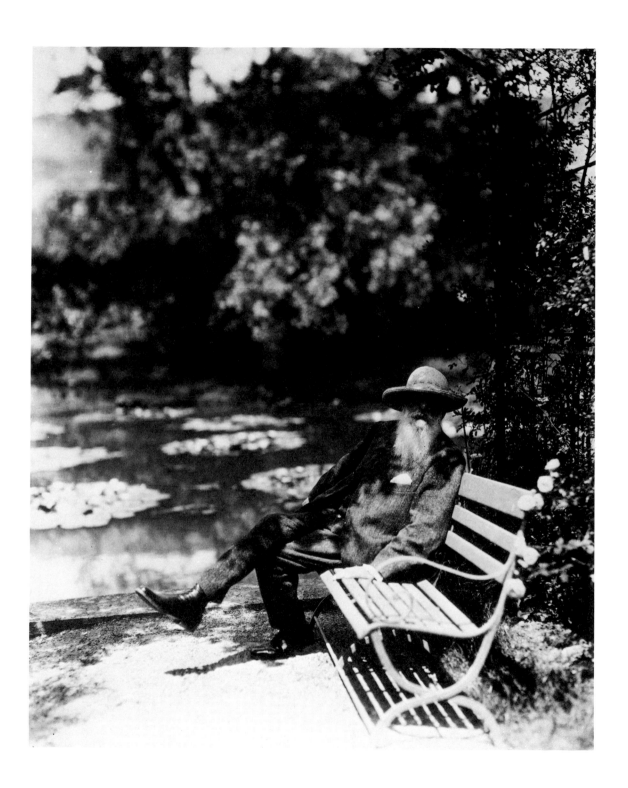

too exhausted to paint, he claimed to have just destroyed sixty canvases.

Terribly emaciated, the invalid had gone through alternate periods of restlessness and exhaustion when his hearty constitution seemed to gain the upper hand once more. On October 4 he announced to Paul Léon: "I have taken courage and despite my weakness have gone back to work, but in very small doses."[31] Was there a slackening in "the advance of the tumor"?[32] Clemenceau, who used the dreaded word on October 18, hoped so, and was ready to come to Monet's side as soon as he was summoned. He renewed his offer to Blanche Hoschedé-Monet on December 1, but by this time Monet was a shadow of his former self. According to Jean-Pierre Hoschedé, he was "calm and not rebellious."[33] On Sunday, December 5, 1926, a telegram was sent to the newspapers from the post office in Vernon: "The painter Claude Monet died at noon at his property in Giverny. M. Georges Clemenceau was with him during his last moments. Claude Monet was eighty-six years old."[34]

The burial took place the following Wednesday about eleven in the morning in the family plot behind the apse of the village church. The ceremony was secular, as Monet had wished it, and was attended by local people and a number of artists, journalists, and dealers, and the impassive Clemenceau. Jacques-Émile Blanche described the scene as "the sad end of a lonely unbeliever, without bells, prayers or incense."[35] Yet the valley of the Seine, in frost and mist that day, recalled the painter's most beautiful creations, whose promises of immortality were the only ones Claude Monet believed.

1. Lionello Venturi, *Les Archives de l'Impressionnisme* (Paris and New York, 1939), I, p. 254.

2. Lila Cabot Perry, "Reminiscences of Claude Monet from 1889 to 1909," *The American Magazine of Art*, no. 3, XVIII, (March 1927), p. 120.

3. Letter, Monet to Durand-Ruel, Giverny, June 5, 1883. Venturi, p. 255.

4. *La Seine! Je l'ai peinte pendant toute ma vie, à toute heure, en toute saison. . . . Je n'en ai jamais été las: elle est pour moi toujours nouvelle. . . .*

 Marc Elder, *À Giverny, chez Claude Monet* (Paris, 1924), p. 35.

5. Letter, Monet to Durand-Ruel, Giverny, June 10, 1883. Venturi, p. 256.

6. *Il paraît que Giverny est un endroit délicieux, et je ne doute pas que vous ne rapportiez une foule de toiles, autant de chefs-d'oeuvre. Je dis une* foule *de toiles, car avec votre prodigieuse activité et votre non moins prodigieuse facilité, peindre, pour vous, c'est, comment dirai-je . . . écrire d'après nature. D'ailleurs, n'est-ce pas à la condition de produire beaucoup qu'un peintre peut passer à la postérité? Songez que vous prenez la succession de Manet et que l'opinion publique vous a placé à la tête du remarquable mouvement artistique dont la France a donné l'exemple. Manet est mort. Vive Monet!*

Letter, de Bellio to Monet, Paris, June 17, 1883 (unpublished). The death of Manet (April 30, 1883) coincides with Monet's arrival in Giverny.

7. Letter, Monet to Durand-Ruel, Giverny, July 3, 1883. Venturi, pp. 257–258.

8. *Monet ne travaille jamais en dehors de l'effet choisi (ne durerait-il que dix minutes) et toujours sur nature. Le peintre n'a pas ce qu'on nomme un atelier. Une espèce de grange, percée d'une large baie, lui sert à rentrer ses toiles. Dans ce local dont le plancher est de terre foulée, il se contente de fumer sa pipe, regardant les études commencées, cherchant le pourquoi d'un défaut. Jamais de retouche à l'atelier. . . . Une fois devant son chevalet, il attaque la peinture d'emblée après quelques traits au fusain, maniant ses longs pinceaux avec une agilité et une sûreté de dessin surprenantes. Il peint à pleine pâte sans mélange, avec quatre ou cinq couleurs franches; il juxtapose ou superpose des tons crus. Son paysage est rapidement installé et peut à la rigueur rester tel après la première séance, qui dure . . . ce que dure 'effet, à peine une heure et souvent beaucoup moins. Il a toujours deux ou trois toiles en train: il les emporte et en change suivant l'effet. C'est sa manière.*

G[eorges] J[eanniot], "Notes sur l'Art, Claude Monet," *La Cravache Parisienne* (June 23, 1888), pp. 1–2.

9. *Il ne faut rien louer, ne commander aucun grillage et jeter les plantes aquatiques à la rivière; elles y pousseront. Donc ne plus m'en parler; je veux peindre. Merde pour les naturels de Giverny, les ingénieurs.*

Letter, Monet to Alice Hoschedé-Monet, Rouen (?), March 20, 1893 (?) (unpublished).

10. *Ce sont des modèles pour une décoration dont il a déjà commencé les études, de grands panneaux qu'il me montra ensuite dans son atelier. . . . Qu'on se figure une pièce circulaire dont la cimaise . . . serait entièrement occupée par un horizon d'eau taché de ces végétations, des parois d'une transparence tour à tour verdie et mauvée, le calme et le silence de l'eau morte reflétant des floraisons étalées; les tons sont imprécis, délicieusement nuancés, d'une délicatesse de songe.*

Maurice Guillemot, "Claude Monet," *La Revue Illustrée*, 13 (March 15, 1898), n. p.

11. Letter, Monet to Durand-Ruel, Giverny, February 7, 1899. Durand-Ruel Archives. Monet and his wife had visited Sisley, who died at Moret-sur-Loing on January 29, 1899.

12. *. . . que mes cathédrales, mes Londres et autres toiles soient faites d'après nature ou non, cela ne regarde personne et ça n'a aucune importance.*

Letter, Monet to Durand-Ruel, Giverny, February 12, 1905. Venturi, p. 401.

13. Louis Vauxcelles, "Un Après-midi chez Claude Monet," *L'Art et les Artistes*, 2 (November 1905), pp. 85 ff.

14. Letter, Monet to Durand-Ruel, Giverny, April 27, 1907. Venturi, p. 409.

15. *Aucune "série" . . . ne vaut, à notre avis, ces fabuleux Paysages d'eau, qui, en ce moment, font de la galerie Durand-Ruel la prison du printemps. Sur l'eau bleu pâle ou bleu sombre, sur l'eau d'or fluide, sur la perfide eau verte, les reflets dessinent le ciel et les rives, et, parmi ces reflets, s'ouvrent et fleurissent les nymphéas livides ou éclatants. Plus que jamais, ici, la peinture touche à la musique et à la poésie; il y a dans ces tableaux une beauté intérieure, raffinée, pénétrante; c'est la gloire d'un spectacle et le plaisir d'un concert. Cette beauté plastique est aussi une beauté idéale.*

Jean-Louis Vaudoyer, in *La Chronique des Arts et de la Curiosité* (May 15, 1909), p. 159.

16. Roger Marx, "Les 'Nymphéas' de M. Claude Monet," *La Gazette des Beaux-Arts*, ser. 4, I (1909), p. 529.

17. Quoted in the interview with the duc de Trévise, "Le Pèlerinage de Giverny," *La Revue de l'Art Ancien et Moderne* (special edition), 51 (January-February 1927), p. 128.

18. From a poem titled "Correspondances":
Comme de longs échos qui de loin se confondent
Dans une ténébreuse et profonde unité,
Vaste comme la nuit et comme la clarté,
Les parfums, les couleurs et les sons se répondent.

Like those deep echoes that meet from afar
In a dark and profound harmony,
As vast as night and clarity,
So perfumes, colors, tones answer each other.

From Charles Baudelaire, *Flowers of Evil*, trans. Geoffrey Wagner (Norfolk, Conn., 1946), n. p.

19. Trévise, pp. 130–131. Most of the canvases 78 inches in height can be considered preparatory studies for the Orangerie

Décorations. Some of the panels (Nos. 76–78, 80), measuring 78 by 157 inches, were not included in the final arrangement.

20. Quoted in Monique Dittière, "Comment Monet recouvra la vue après l'opération de la cataracte," *Sandorama*, 32 (January-February 1973), p. 27.

21. The letter, from Giverny, is dated November 7, 1922, and is quoted in P. Gassier, "Monet et Rodin photographiés chez eux en couleur," *Connaissance des Arts*, 278 (April 1975), p. 96.

22. An undated note in Monet's hand (unpublished).

23. Letter, Clemenceau to Monet, April 15, 1923. Typed copy, formerly collection of Blanche Hoschedé-Monet.

24. Letter, Coutela to Clemenceau, Paris, September 6, 1923. Typed copy, formerly collection of Blanche Hoschedé-Monet.

25. Letter, Clemenceau to Monet, Paris, March 1, 1924. Typed copy, formerly collection of Blanche Hoschedé-Monet.

26. Letter, Clemenceau to Monet, Saint-Vincent-sur-Jard (Vendée), August 1, 1924. Typed copy, formerly collection of Blanche Hoschedé-Monet.

27. Monet's remarks are reported by Mawas and quoted in Dittière, p. 31.

28. Letter, Clemenceau to Monet, Paris, January 7, 1925. Typed copy, formerly collection of Blanche Hoschedé-Monet.

29. Monet to Barbier, Giverny, July 17, 1925. Quoted in Jean-Pierre Hoschedé, *Claude Monet, Ce Mal Connu* (Geneva, 1960), I, p. 151; and idem, *Blanche Hoschedé-Monet* (Rouen, 1961), pp. 16–17.

30. Letter, Clemenceau to Monet, Saint-Vincent-sur-Jard, August 19, 1925. Typed copy, formerly collection of Blanche Hoschedé-Monet.

31. Letter, Monet to Léon, Giverny, October 4, 1926. Gift of M. J.-P. Léon to the Académie des Beaux-Arts, Musée Marmottan, Paris.

32. Letter, Clemenceau to Blanche Hoschedé-Monet, Paris, October 18, 1926. Quoted in J.-P. Hoschedé, *Blanche Hoschedé-Monet*, p. 50.

33. J.-P. Hoschedé, *Claude Monet*, p. 153.

34. Reprinted following Louis Gillet, "Claude Monet," *Le Gaulois* (December 6, 1926).

35. *Lugubre fin de solitaire incroyant, sans cloches, ni prières, ni encens.*

 J.-É. Blanche, "Claude Monet," *La Revue de Paris* (February 1, 1927), p. 562.

THE EIGHTIES

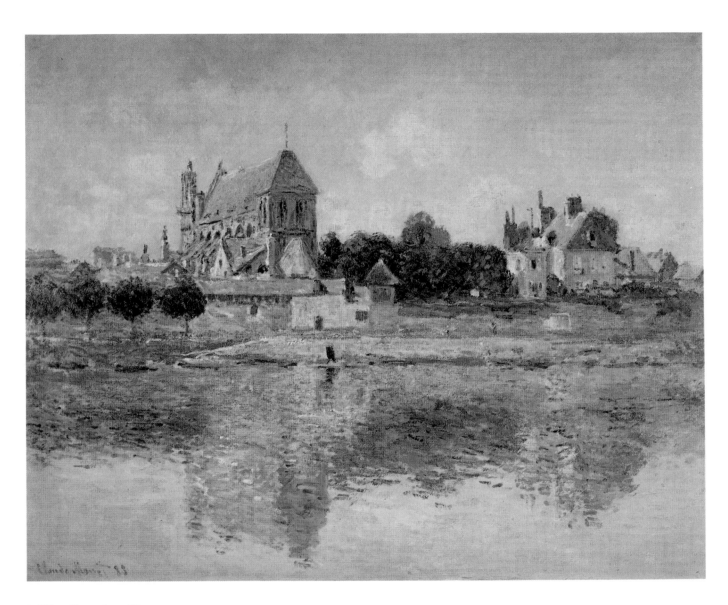

1. The Church at Vernon

Signed and dated, lower left: *Claude Monet 83*
Oil on canvas; 25¾ × 32 in. (65.4 × 81.3 cm.)
Lent anonymously

2. Autumn on the Seine

Signed and dated, lower right: *Claude Monet 84*
Oil on canvas; 23⅜ × 28½ in. (59.4 × 72.4 cm.)
Museum of Fine Arts, Boston
Juliana Cheney Edwards Collection
Bequest of Grace M. Edwards in memory of her Mother
 (39.656)

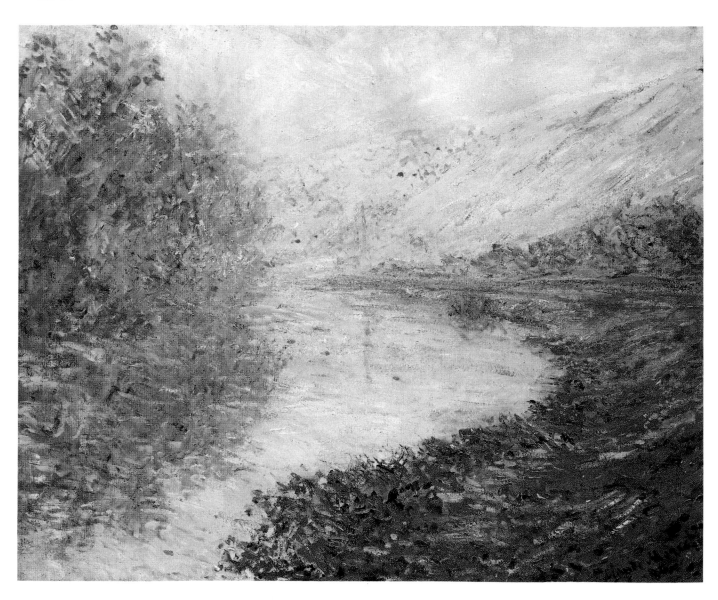

3. Banks of the Seine at Jeufosse, Autumn

Signed and dated, lower right: *Claude Monet 84*
Oil on canvas; 21½ × 29 in. (54.6 × 73.6 cm.)
Collection of Mr. and Mrs. Nathan L. Halpern

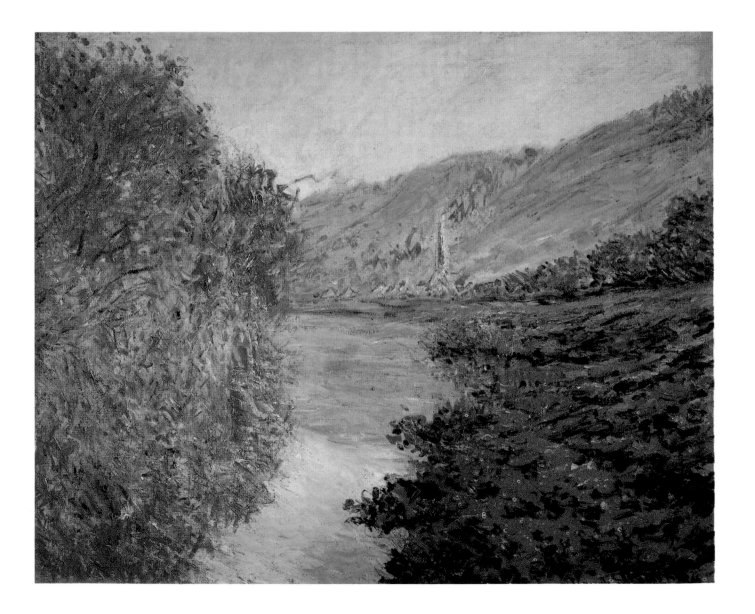

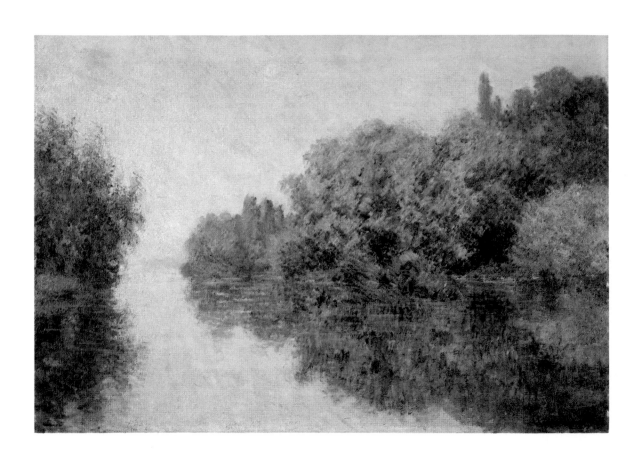

4. The Seine at Giverny

Signed and dated, lower right: *Claude Monet 85*
Oil on canvas; 25 ½ × 36½ in. (64.8 × 92.7 cm.)
Museum of Art, Rhode Island School of Design (44.541)

5. Poppy Field in a Hollow near Giverny

Signed and dated, lower left: *Claude Monet 85*
Oil on canvas; 25 ¾ × 32 in. (65.4 × 81.3 cm.)
Museum of Fine Arts, Boston
Juliana Cheney Edwards Collection
Bequest of Robert J. Edwards in memory of his Mother (25.106)

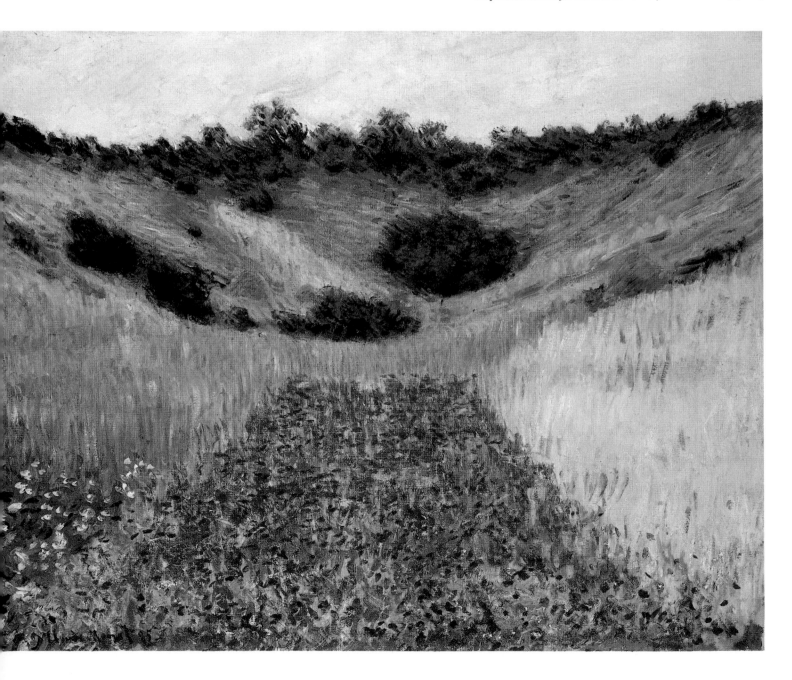

6. Spring at Giverny

Signed and dated, lower right: *Claude Monet 86*
Oil on canvas; 21¾ × 26 in. (55.2 × 66 cm.)
Collection of Mr. and Mrs. David Lloyd Kreeger

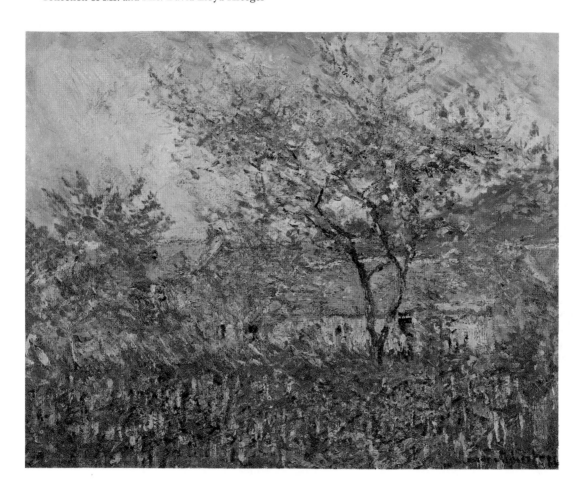

7. The Boat

About 1887
Oil on canvas; 57½ × 52⅜ in. (146 × 133 cm.)
Collection of the Musée Marmottan, Paris (5082)

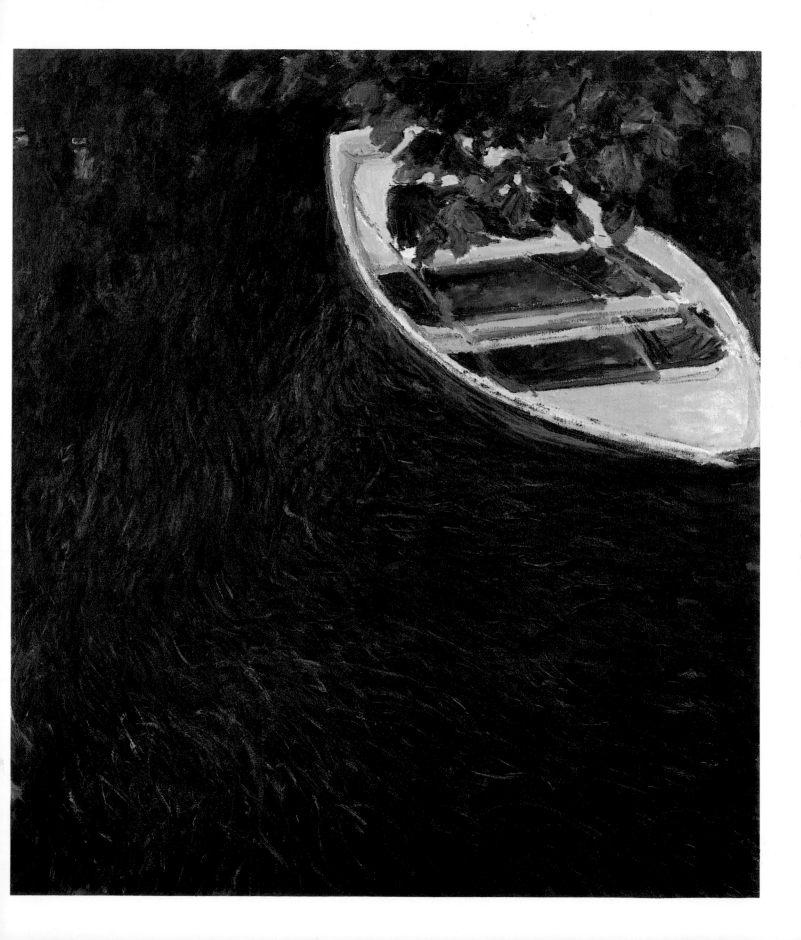

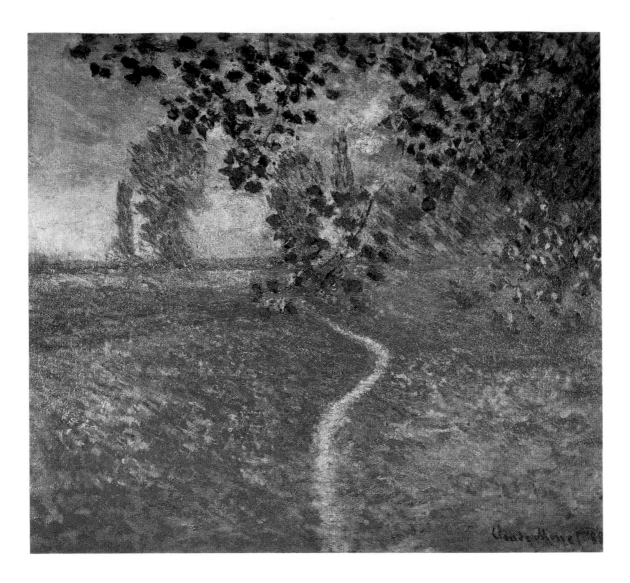

8. Morning Landscape

Signed and dated, lower right: *Claude Monet 88*
Oil on canvas, 29¹⁄₁₆ × 31½ in. (73.8 × 80 cm.)
Lent anonymously

9. A Bend in the Epte River, near Giverny

Signed and dated, lower right: *Claude Monet 88*
Oil on canvas; 29⅛ × 36½ in. (74 × 92.7 cm.)
Philadelphia Museum of Art
William L. Elkins Collection (E′24-3-16)

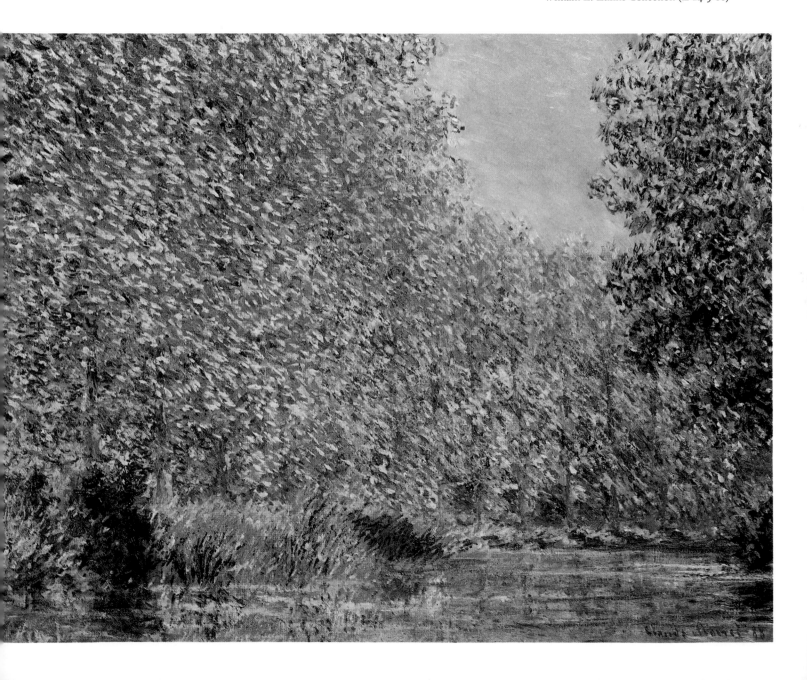

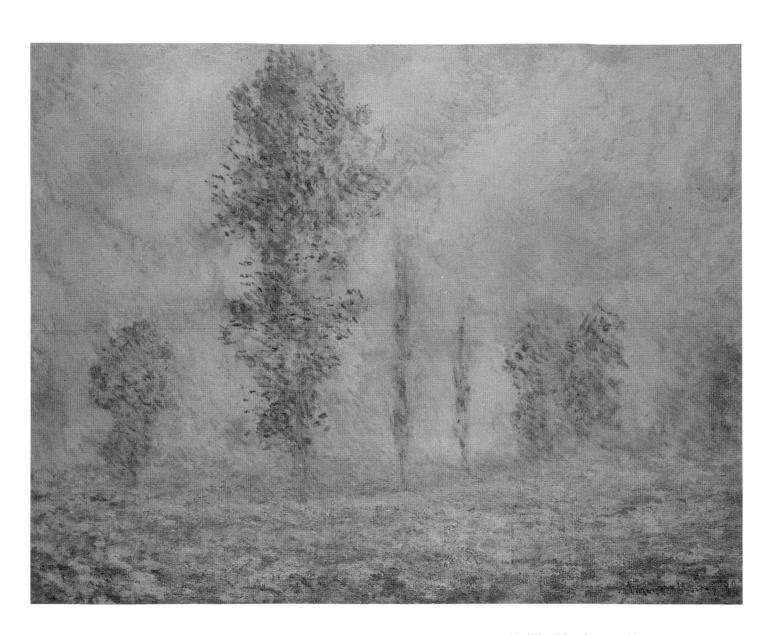

10. The Meadow at Giverny

Signed and dated, lower right: *Claude Monet 88*
Oil on canvas; 29 × 36½ in. (73.7 × 92.7 cm.)
Lent anonymously

HAYSTACKS

11. Haystacks at Noon

Signed and dated, lower left: *Claude Monet 90*
Oil on canvas; 25¾ × 39½ in. (65.4 × 100.3 cm.)
Lent anonymously

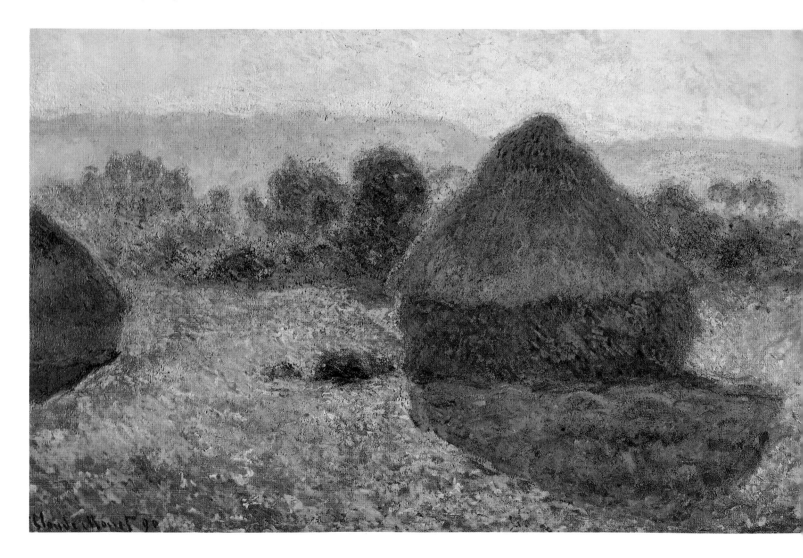

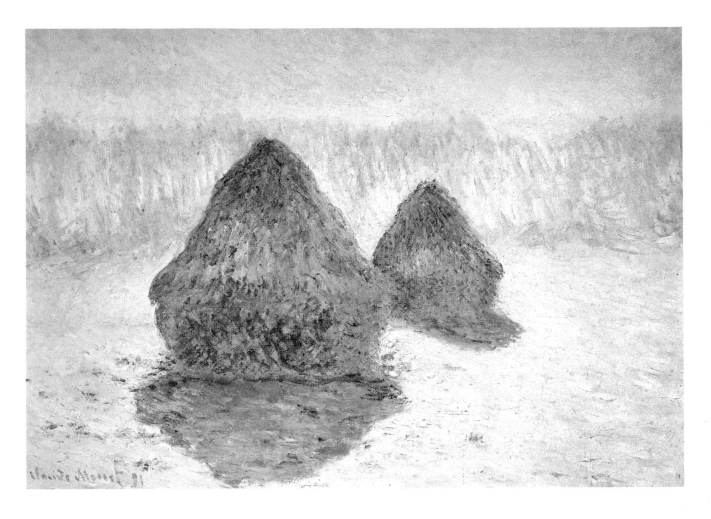

12. Haystacks in the Snow

Signed and dated, lower left: *Claude Monet 91*
Oil on canvas; 25¾ × 36¼ in. (65.4 × 92.1 cm.)
The Metropolitan Museum of Art
Bequest of Mrs. H. O. Havemeyer, 1929.
The H. O. Havemeyer Collection (29.100.109)

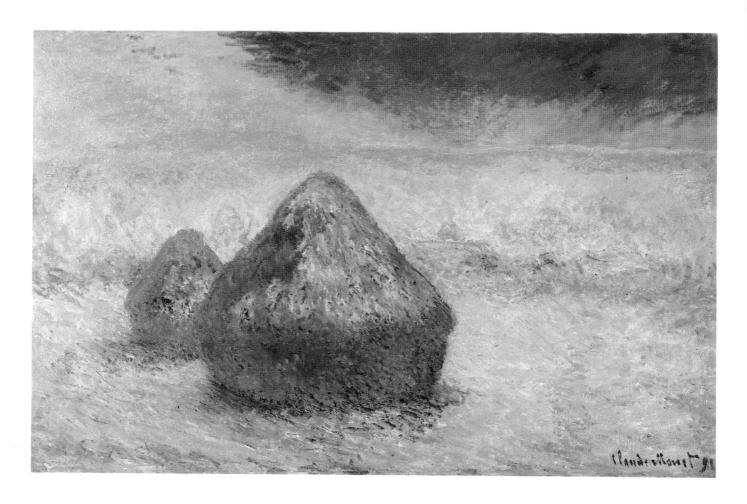

13. Haystacks, Setting Sun

Signed and dated, lower right: *Claude Monet 91*
Oil on canvas; 25½ × 39½ in. (64.8 × 100.3 cm.)
The Art Institute of Chicago
The Potter Palmer Collection (22.431)

14. Haystack at Sunset

Signed and dated, lower left: *Claude Monet 91*
Oil on canvas; 28¾ × 36¼ in. (73 × 92.1 cm.)
Museum of Fine Arts, Boston
Juliana Cheney Edwards Collection
Bequest of Robert J. Edwards in memory of his Mother (25.112)

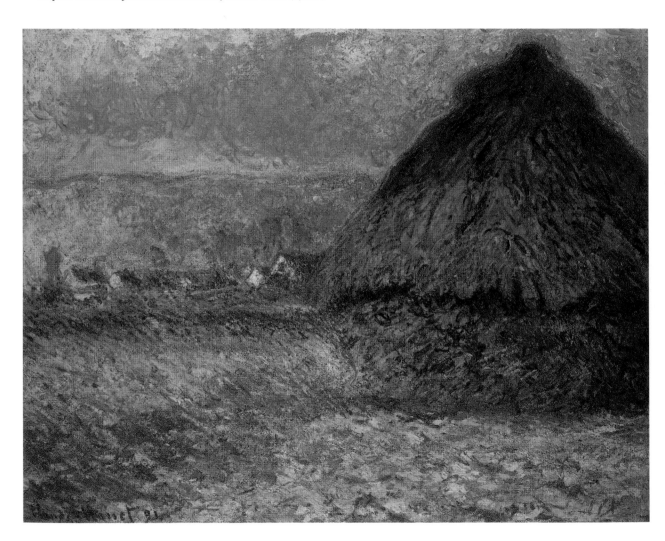

15. Two Haystacks

Signed and dated, lower left: *Claude Monet 91*
Oil on canvas; 25½ × 39¼ in. (64.8 × 99.7 cm.)
The Art Institute of Chicago
Mr. and Mrs. Lewis L. Coburn Memorial Collection (33.444)

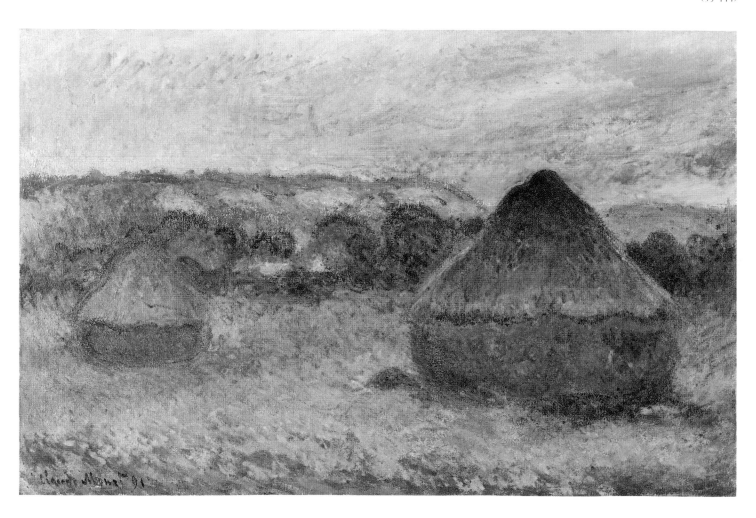

POPLARS

16. Poplars

Signed and dated, lower left: *Claude Monet 91*
Oil on canvas; 32¼ × 32⅛ in. (81.9 × 81.6 cm.)
The Metropolitan Museum of Art
Bequest of Mrs. H. O. Havemeyer, 1929.
The H. O. Havemeyer Collection (29.100.110)

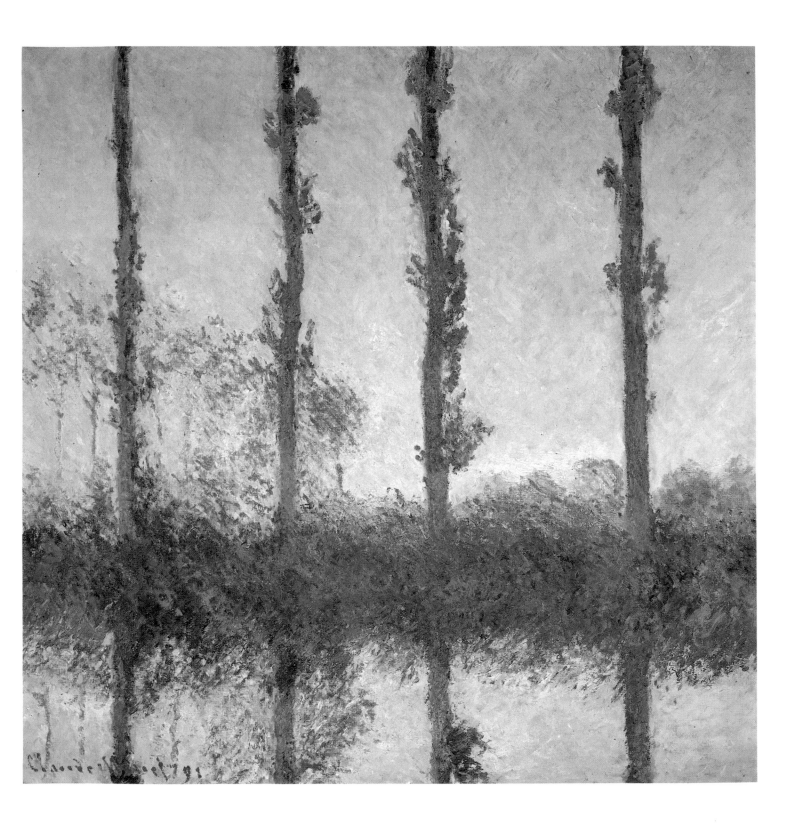

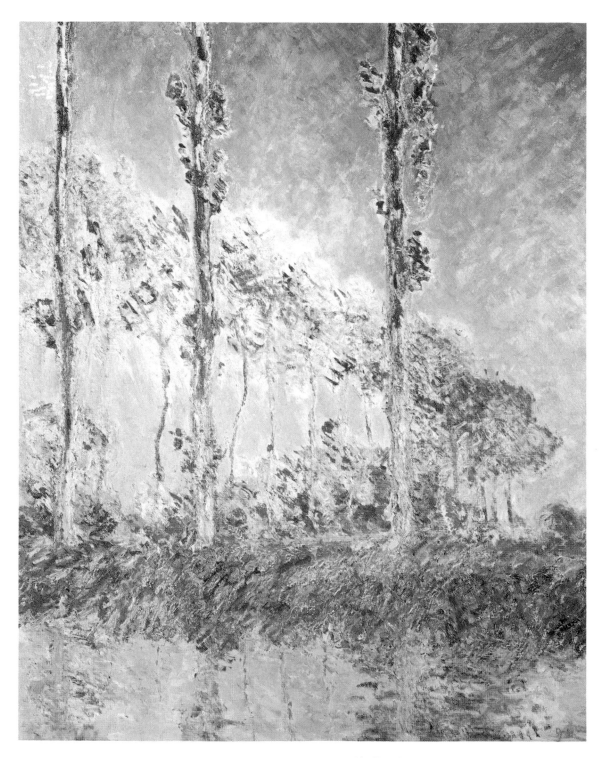

17. Poplars

Signed and dated, lower right: *Claude Monet 91*
Oil on canvas; 36¼ × 29 in. (92.1 × 73.7 cm.)
Philadelphia Museum of Art
Gift of Chester Dale ('51-109-1)

18. Poplars

Signed and dated, lower left: *Claude Monet 91*
Oil on canvas; 37¼ × 29¼ in. (94.6 × 74.3 cm.)
Lent anonymously

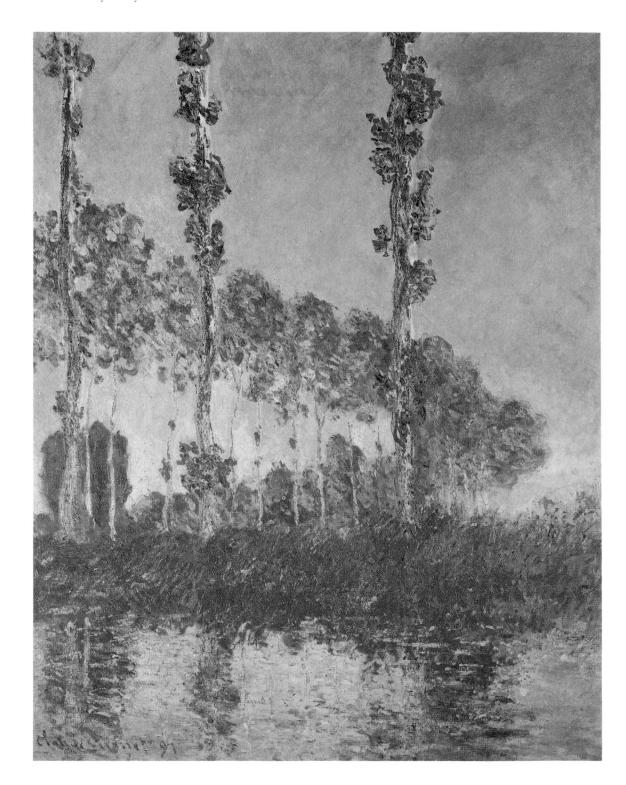

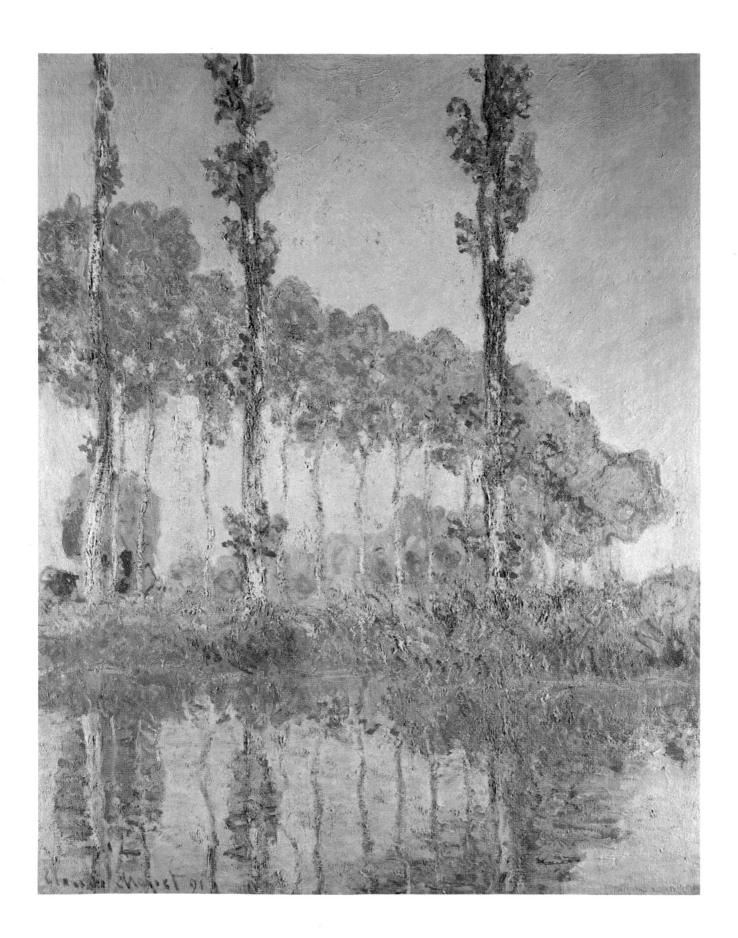

19. Pink Poplars

Signed and dated, lower left: *Claude Monet 91*
Oil on canvas; 36⅞ × 29⅛ in. (93.7 × 74 cm.)
Lent anonymously

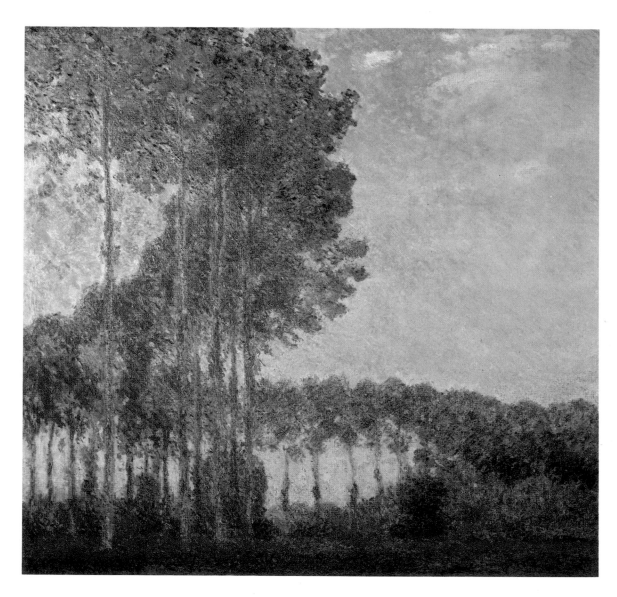

20. Poplars in the Sun

Signed and dated, lower left: *Claude Monet 91*
Oil on canvas; 34¾ × 36½ in. (88.3 × 92.7 cm.)
Lent anonymously

THE RIVER AND THE FIELDS

21. Field of Poppies

Signed and dated, lower right: *Claude Monet 90*
Oil on canvas; 23½ × 39½ in. (59.7 × 100.3 cm.)
Smith College Museum of Art, Northampton, Massachusetts
Gift of the Honorable and Mrs. Irwin Untermyer, 1940 (1940: 10-1)

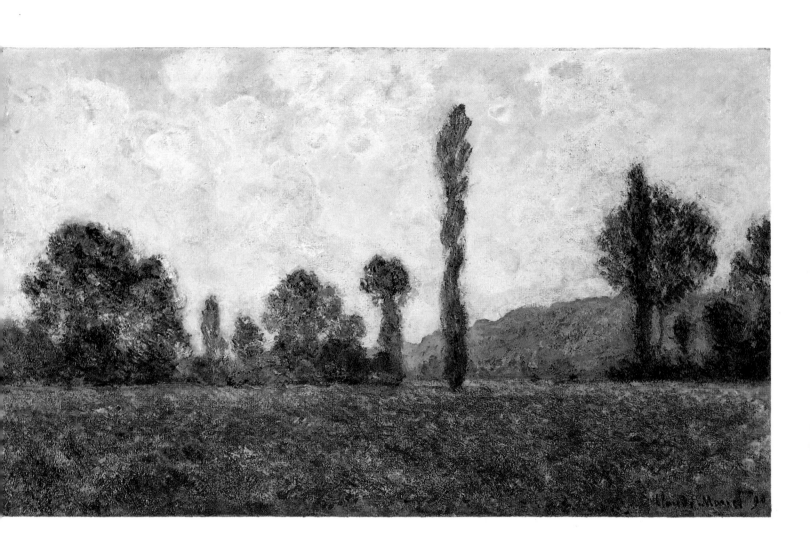

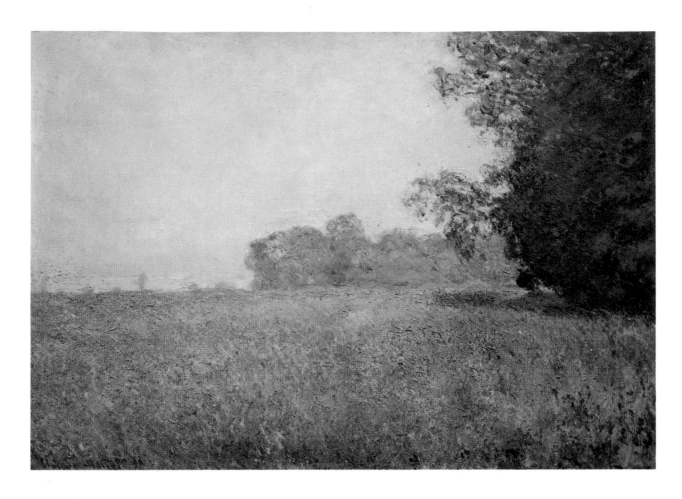

22. The Oat Field

Signed and dated, lower left: *Claude Monet 90*
Oil on canvas; 25¼ × 35¾ in. (64.1 × 90.8 cm.)
Lent anonymously

23. The Ice Floe

Signed and dated, lower right: *Claude Monet 93*
Oil on canvas; 26 × 39½ in. (66 × 100.3 cm.)
The Metropolitan Museum of Art
Bequest of Mrs. H. O. Havemeyer, 1929.
The H. O. Havemeyer Collection (29.100.108)

24. Haystack in Field

Signed and dated, lower left: *Claude Monet 93*
Oil on canvas; 26 × 40 in. (66 × 101.6 cm.)
Museum of Fine Arts, Springfield, Massachusetts
The James Philip Gray Collection (44.06)

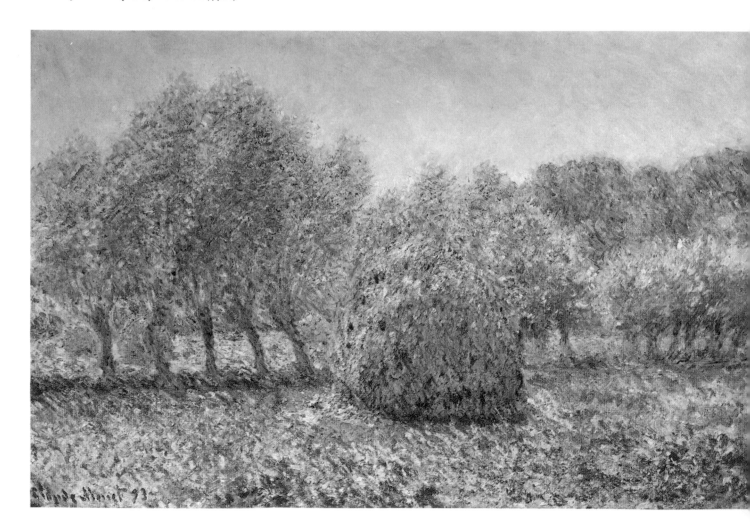

MORNING ON THE SEINE

25. Morning on the Seine, Giverny

Signed and dated, lower left: *Claude Monet 97*
Oil on canvas; 32 × 36½ in. (81.3 × 92.7 cm.)
Amherst College Collection
Bequest of Miss Susan Dwight Bliss (1966.48)

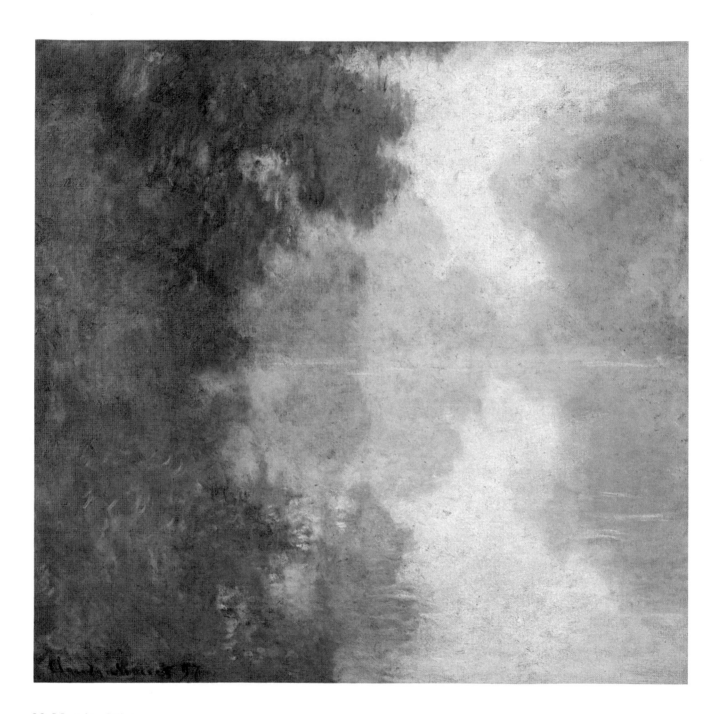

26. Morning Mists

Signed and dated, lower left: *Claude Monet 97*
Oil on canvas; 35 × 36 in. (88.9 × 91.4 cm.)
Collection of the North Carolina Museum of Art
Gift of the Sarah Graham Kenan Foundation and the
 North Carolina Art Society, Raleigh (6.75.24.1)

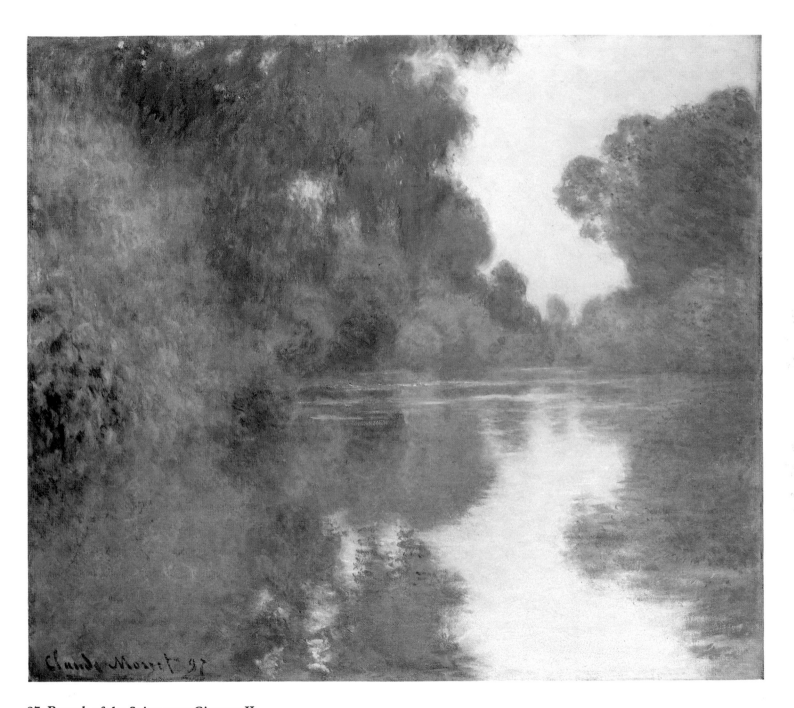

27. Branch of the Seine near Giverny II

Signed and dated, lower left: *Claude Monet 97*
Oil on canvas; 32⅛ × 36⅜ in. (81.6 × 92.4 cm.)
Museum of Fine Arts, Boston
Gift of Mrs. Walter Scott Fitz (11.1261)

28. Morning on the Seine, near Giverny

Signed and dated, lower left: *Claude Monet 97*
Oil on canvas; 32⅛ × 36⅝ in. (81.6 × 93.1 cm.)
The Metropolitan Museum of Art
Bequest of Julia W. Emmons, 1956 (56.135.4)

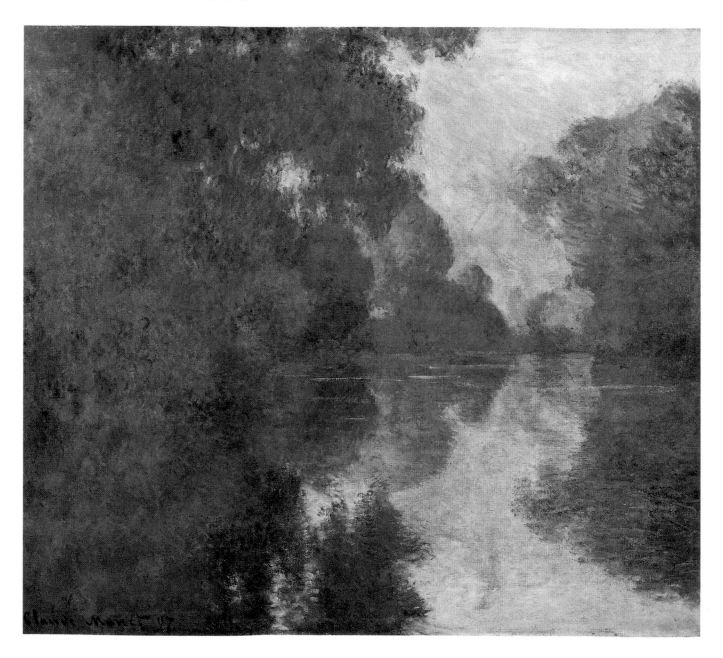

THE JAPANESE FOOTBRIDGE

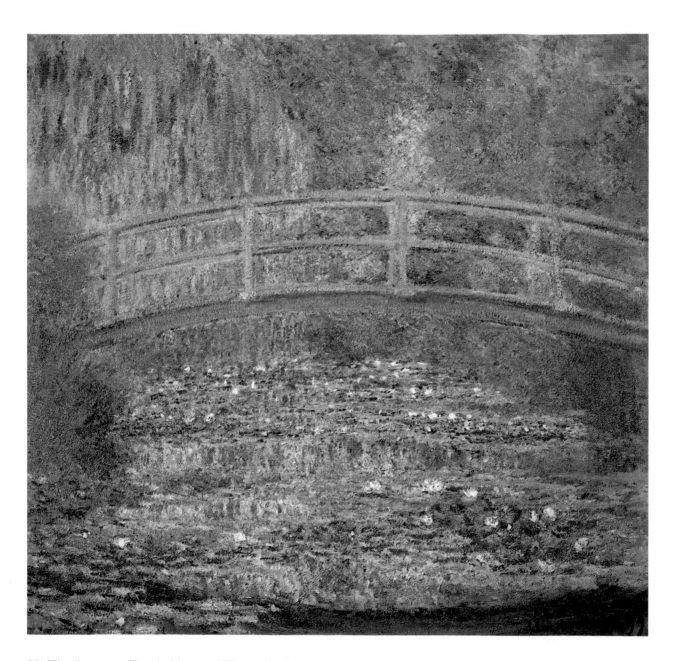

29. The Japanese Footbridge and Water Garden, Giverny

Signed and dated, lower right: *Claude Monet 99*
Oil on canvas; 36½ × 35½ in. (92.7 × 90.2 cm.)
Lent anonymously

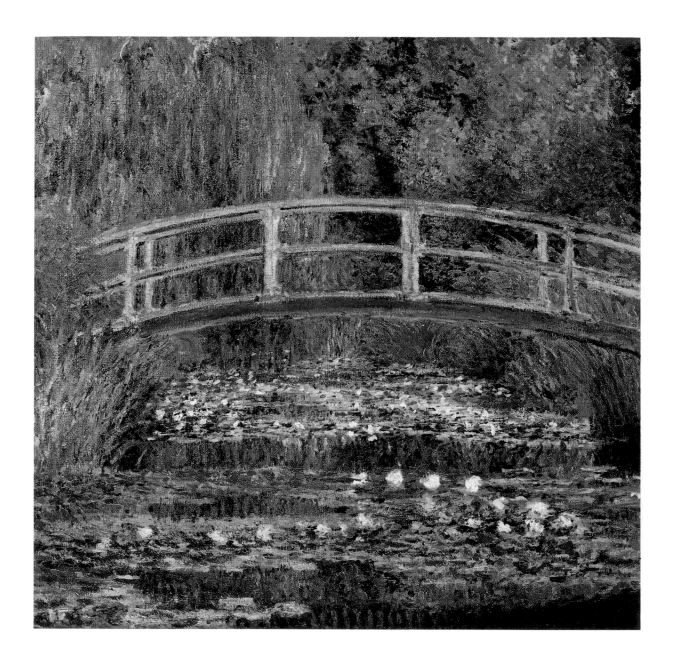

30. Water Lilies and Japanese Bridge

Signed and dated, lower right: *Claude Monet 99*
Oil on canvas; 35⅝ × 35⅞₆ in. (90.5 × 90 cm.)
The Art Museum, Princeton University
From the Collection of William Church Osborn, Class of 1883,
 Trustee of Princeton University (1914–1951), President of the
 Metropolitan Museum of Art (1941–1947); given by his family
 (72-15)

31. A Bridge over a Pool of Water Lilies

Signed and dated, lower right: *Claude Monet 99*
Oil on canvas; 36½ × 29 in. (92.7 × 73.7 cm.)
The Metropolitan Museum of Art
Bequest of Mrs. H. O. Havemeyer, 1929.
The H. O. Havemeyer Collection (29.100.113)

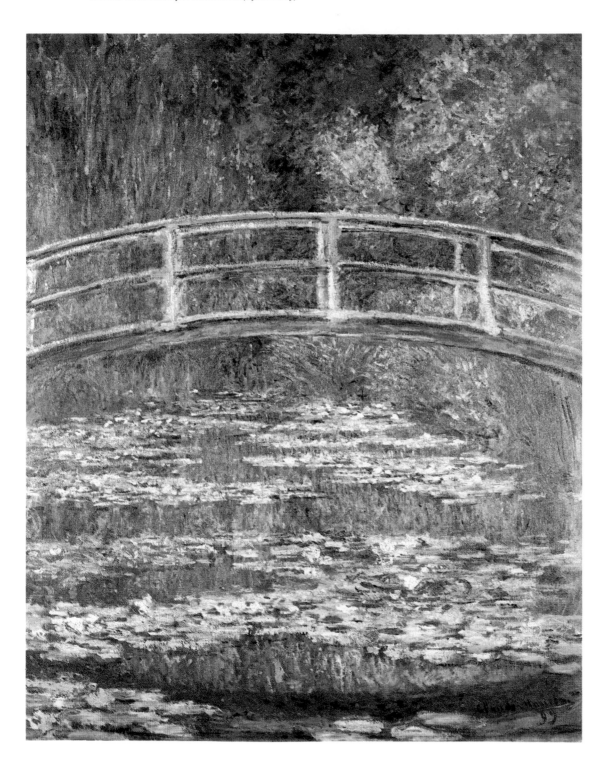

32. The Japanese Footbridge and the Water Lily Pool, Giverny

Signed and dated, lower right: *Claude Monet 99*
Oil on canvas; 36⅝ × 35⁷⁄₁₆ in. (93 × 90 cm.)
Collection of Mr. and Mrs. David T. Schiff

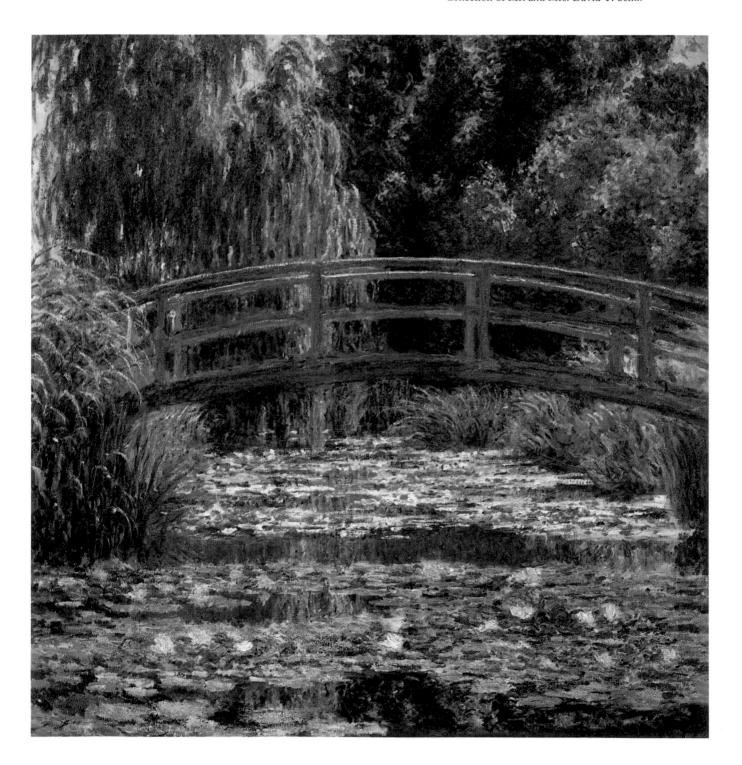

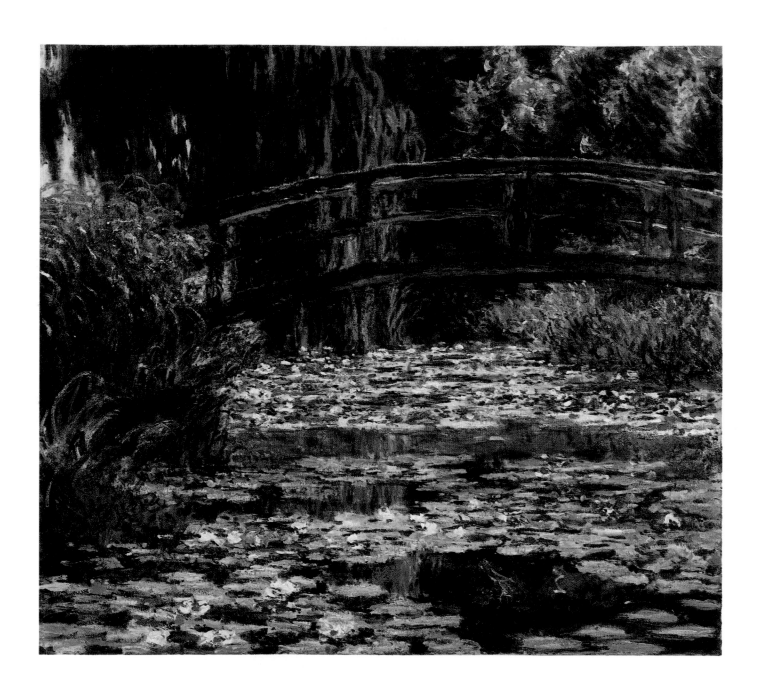

33. Pool of Water Lilies

Signed and dated, upper left: *Claude Monet 1900*
Oil on canvas; 35 1/8 × 39 1/2 in. (89.2 × 100.3 cm.)
The Art Institute of Chicago
Mr. and Mrs. Lewis L. Coburn Memorial Collection (33.441)

THE GARDEN PATH

34. The Garden at Giverny

Signed and dated, lower right: *Claude Monet 1900*
Oil on canvas; 31¾ × 35¾ in. (80.6 × 90.8 cm.)
Collection of Ralph T. Coe

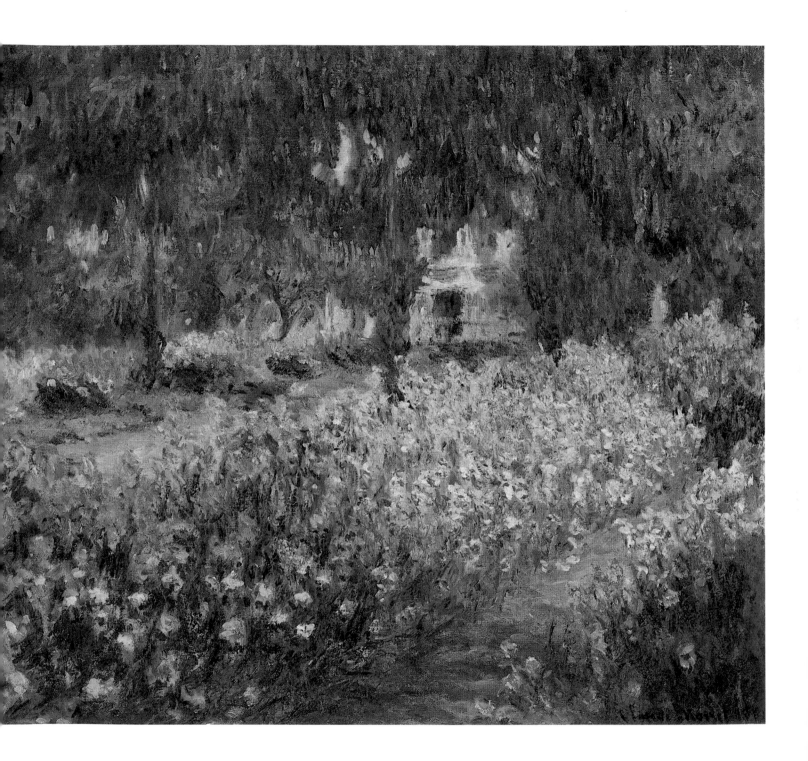

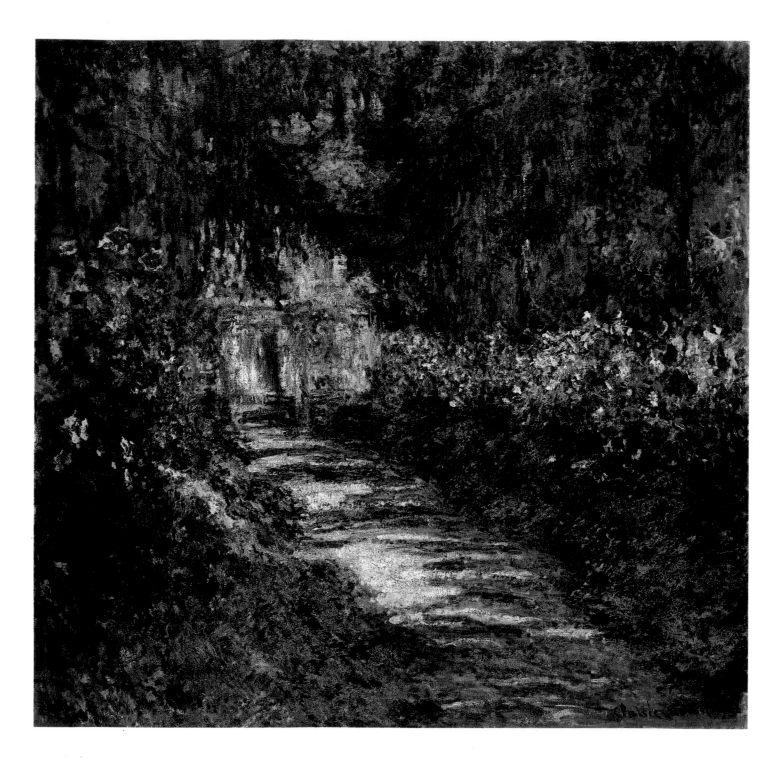

35. The Garden Path, Giverny

Signed and dated, lower right: *Claude Monet 1900*
Oil on canvas; 35 × 36 in. (88.9 × 91.4 cm.)
Lent anonymously

36. The Garden Path at Giverny

Signed and dated, lower right: *Claude Monet 1902*
Oil on canvas; 31 ⅛ × 35 ½ in. (79.1 × 90.2 cm.)
Collection of Mr. and Mrs. David T. Schiff

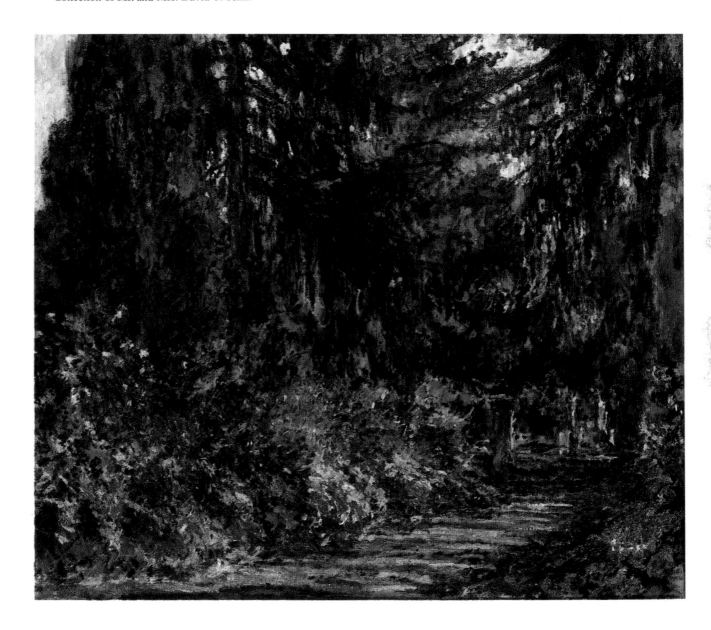

EARLY WATER LILIES

37. Water Lilies

Signed and dated, lower left: *Claude Monet 1903*
Oil on canvas; 32 × 40 in. (81.3 × 101.6 cm.)
The Dayton Art Institute
Gift of Mr. Joseph Rubin (53.11)

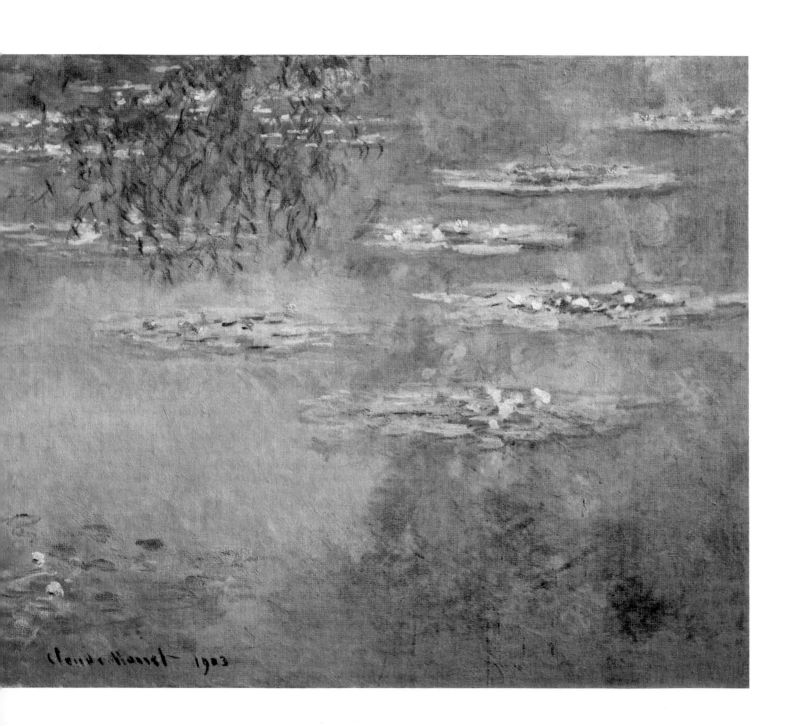

38. The Cloud

Signed and dated, lower right: *Claude Monet 03*
Oil on canvas; 24½ × 42 in. (62.2 × 106.7 cm.)
Lent anonymously

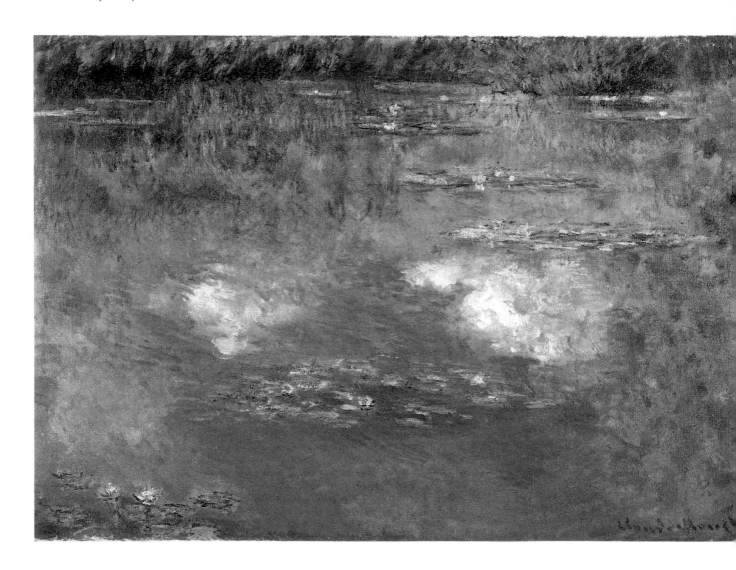

39. Water Lilies

Signed and dated, lower right: *Claude Monet 1904*
Oil on canvas; 34½ × 35¾ in. (87.6 × 90.8 cm.)
The Denver Art Museum
The Helen Dill Collection

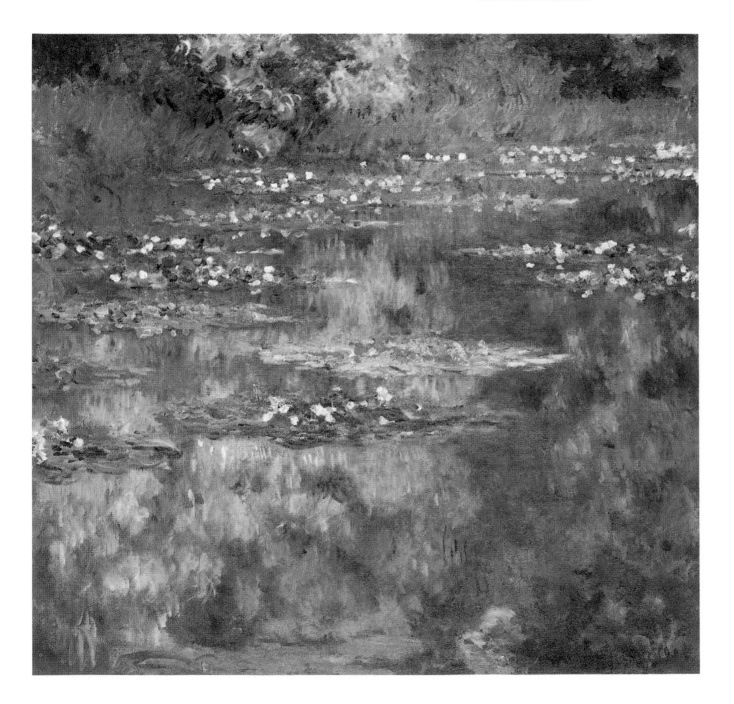

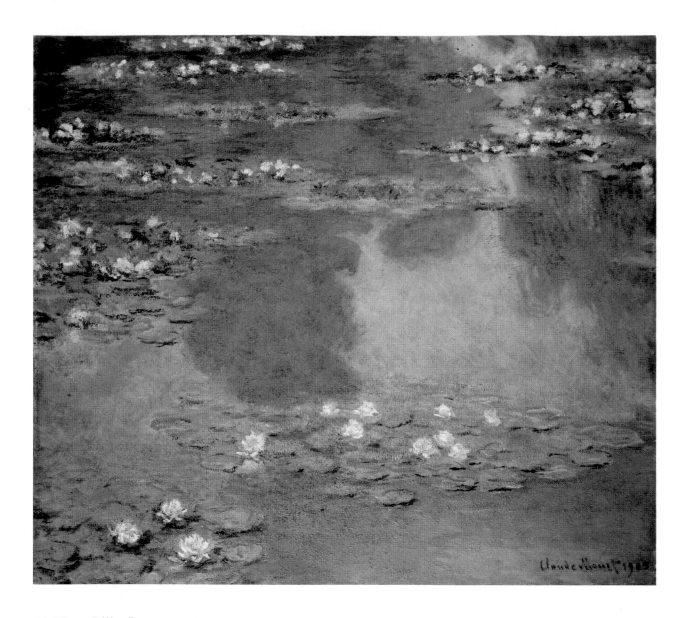

40. Water Lilies I

Signed and dated, lower right: *Claude Monet 1905*
Oil on canvas; 35¼ × 39⅜ in. (89.5 × 100 cm.)
Museum of Fine Arts, Boston
Gift of Edward Jackson Holmes (39.804)

41. Water Lilies

About 1905
Signed, lower right: *Claude Monet*
Oil on canvas; 35 1/16 × 39 3/8 in. (89 × 100 cm.)
Lent anonymously

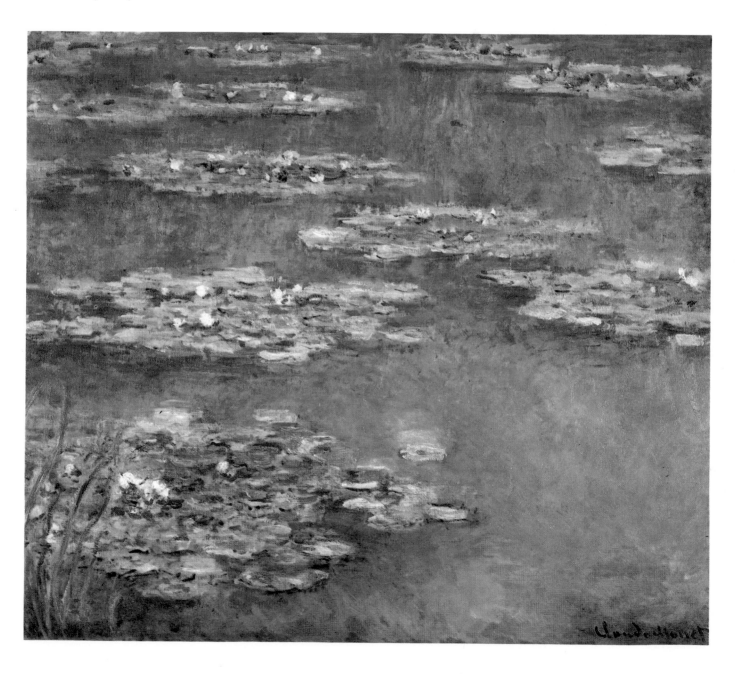

42. Water Lilies

Signed and dated, lower right: *Claude Monet 1907*
Oil on canvas; 31⅞ × 36¼ in. (81 × 92.1 cm.)
Wadsworth Atheneum, Hartford
Bequest of Anne Parrish Titzell

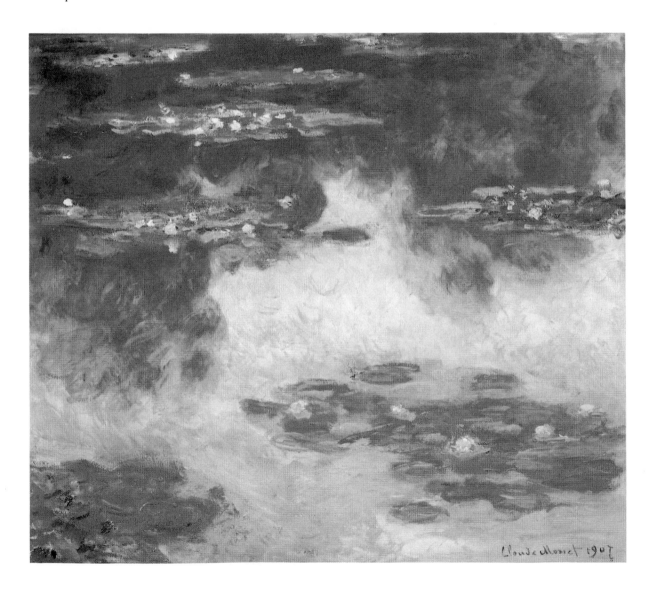

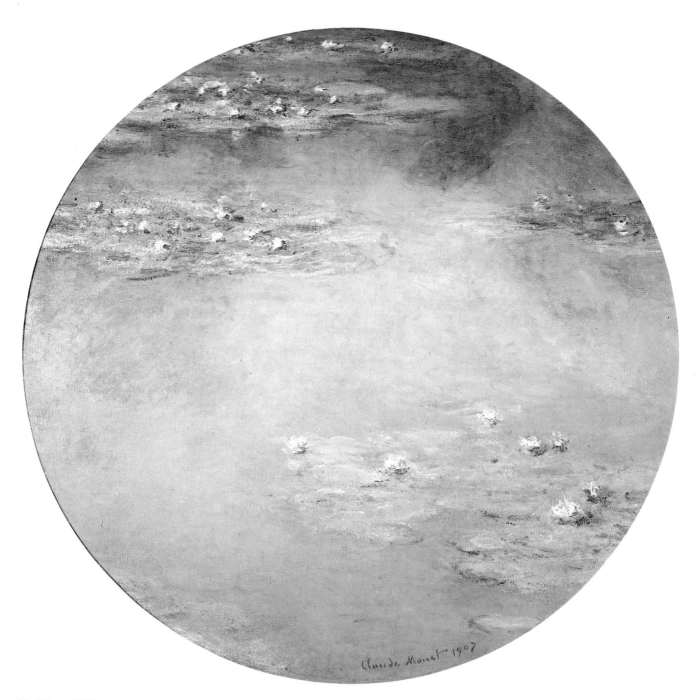

43. Water Lilies

Signed and dated, lower right: *Claude Monet 1907*
Oil on canvas; D. 31½ in. (80 cm.)
Lent anonymously

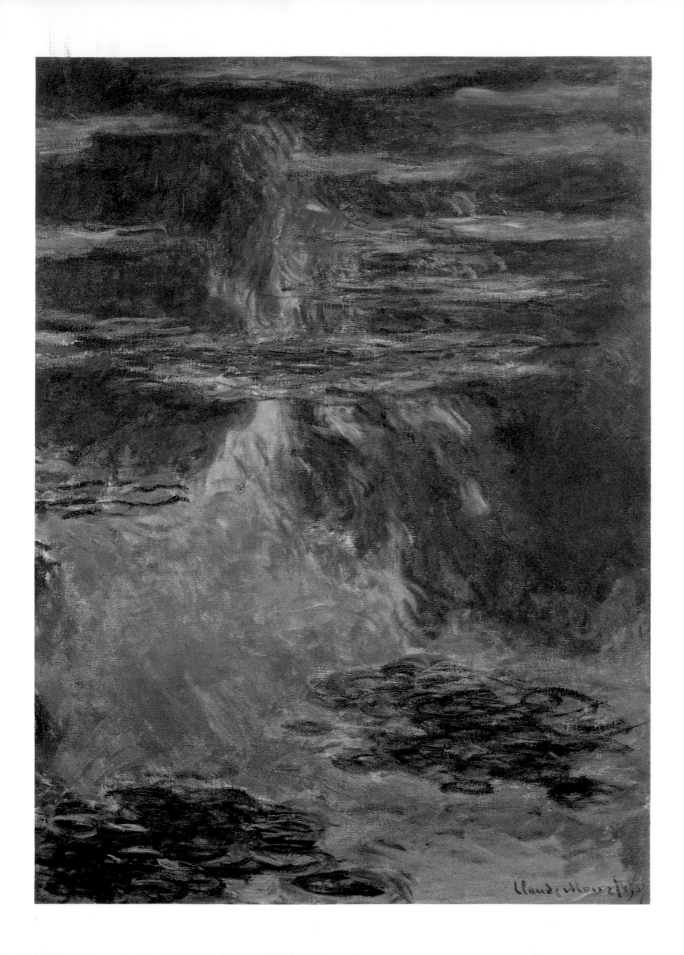

44. Water Lilies—Evening Effect

Signed and dated, lower right: *Claude Monet 1907*
Oil on canvas; 39⅜ × 28¾ in. (100 × 73 cm.)
Collection of the Musée Marmottan, Paris (5168)

45. The Flowering Arches

1913
Signed, lower left: *Claude Monet*
Oil on canvas; 31⅞ × 36 in. (81 × 91.4 cm.)
Phoenix Art Museum
Gift of Mr. and Mrs. Donald D. Harrington (64-321)

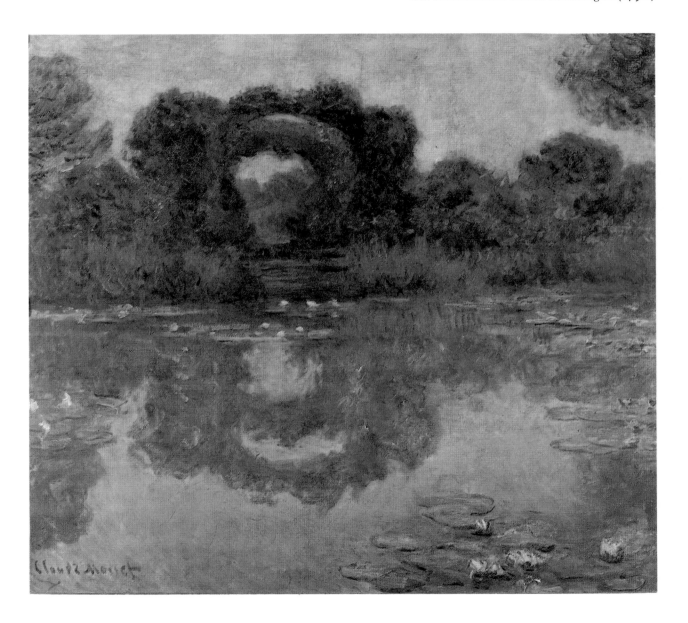

THE LATE SERIES

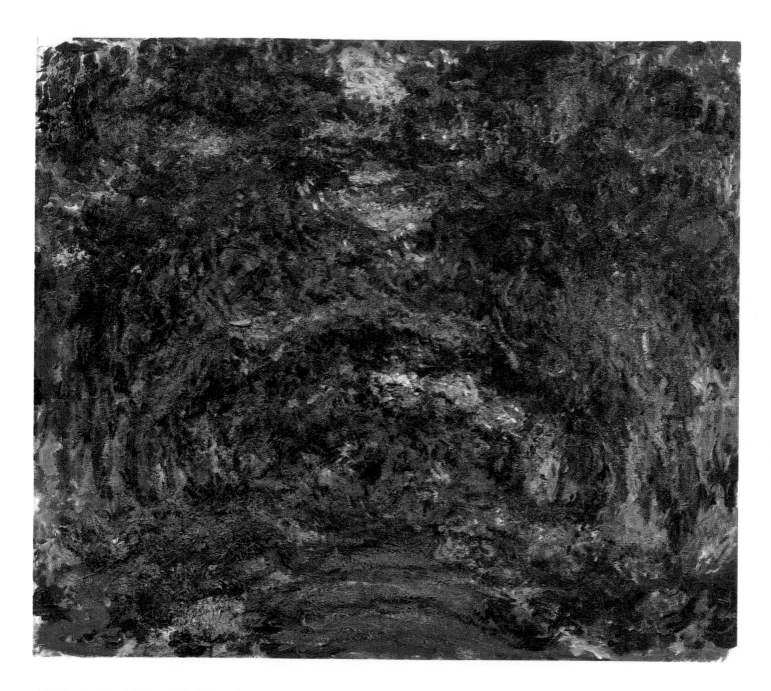

46. The Path with Rose Trellises, Giverny

About 1922 (?)
Oil on canvas; 35 1/16 × 39 3/8 in. (89 × 100 cm.)
Collection of the Musée Marmottan, Paris (5089)

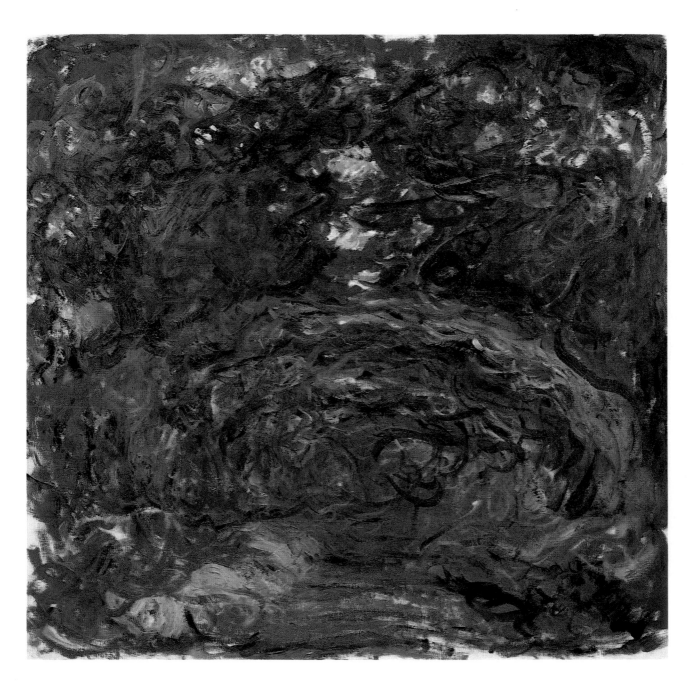

47. The Path with Rose Trellises, Giverny

About 1922 (?)
Oil on canvas; 35⅞₁₆ × 36⅜₁₆ in. (90 × 92 cm.)
Collection of the Musée Marmottan, Paris (5088)

48. The Path with Rose Trellises, Giverny

About 1922 (?)
Oil on canvas; 36³⁄₁₆ × 35¹⁄₁₆ in. (92 × 89 cm.)
Collection of the Musée Marmottan, Paris (5104)

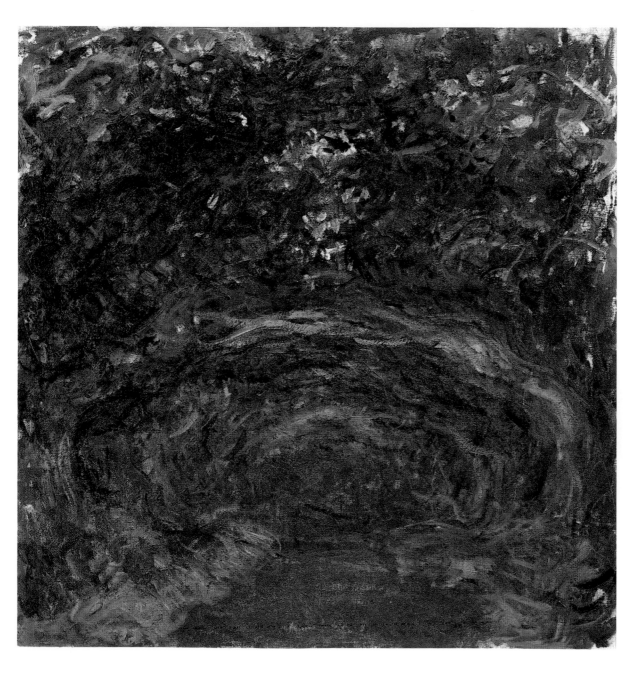

49. The Path with Rose Trellises, Giverny

About 1922 (?)
Oil on canvas; 31⅞ × 39⅜ in. (81 × 100 cm.)
Collection of the Musée Marmottan, Paris (5090)

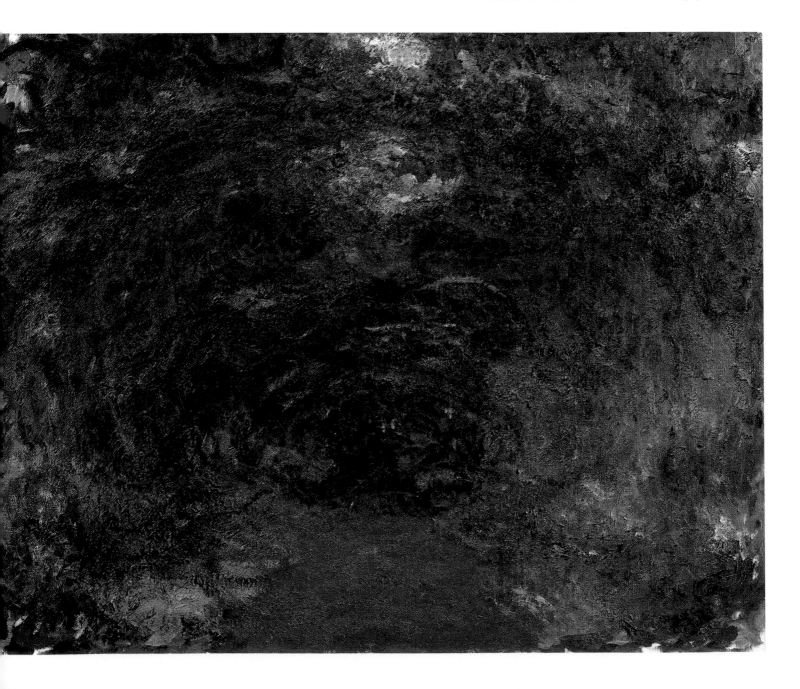

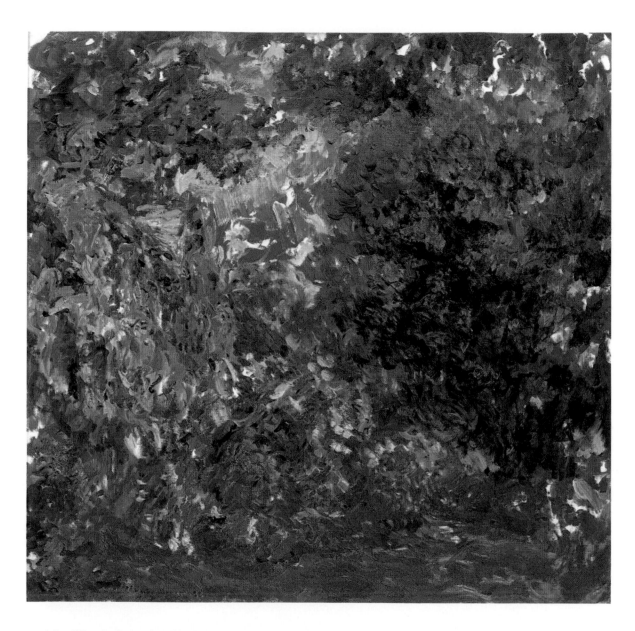

50. The House from the Garden

Signed and dated, lower left: *Claude Monet 22*
Oil on canvas; 35⅟₁₆ × 36³⁄₁₆ in. (89 × 92 cm.)
Collection of the Musée Marmottan, Paris (5108)

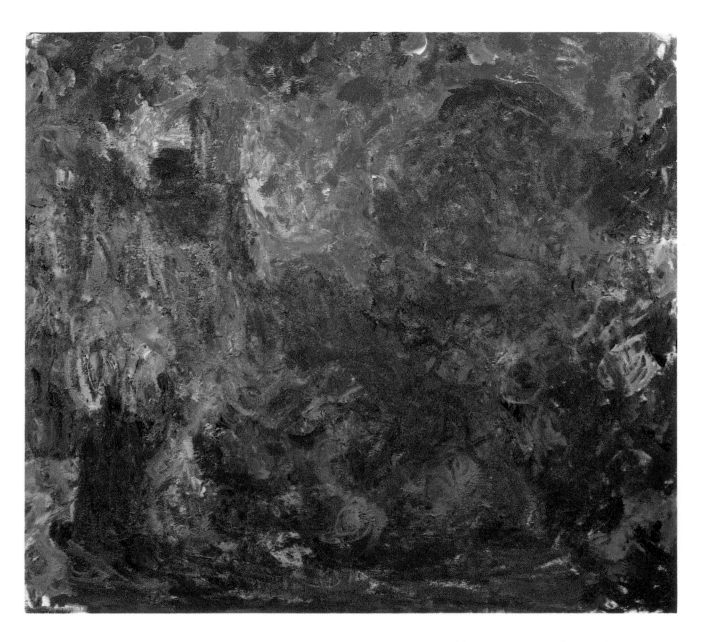

51. The House from the Garden

About 1922
Oil on canvas; 31 7/8 × 36 3/16 in. (81 × 92 cm.)
Collection of the Musée Marmottan, Paris (5086)

52. The House from the Garden

About 1922
Oil on canvas; 31 ⅞ × 36 ⅝ in. (81 × 93 cm.)
Collection of the Musée Marmottan, Paris (5087)

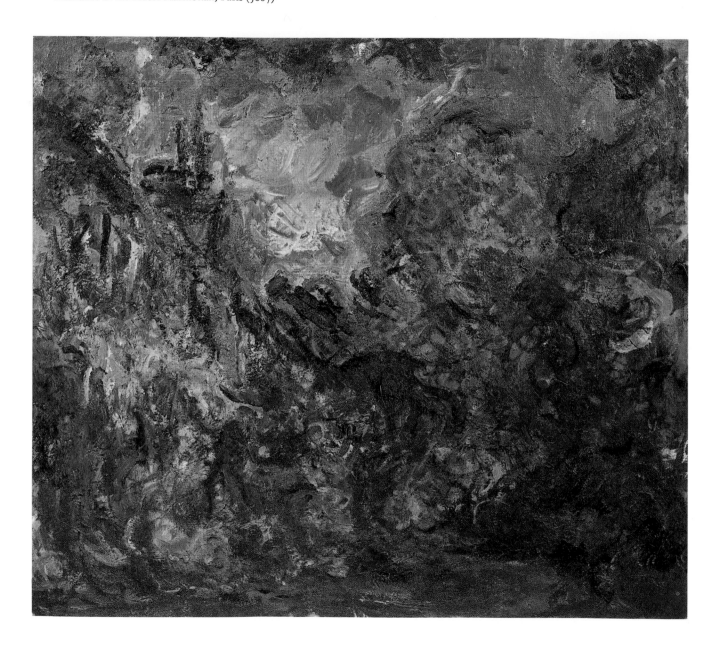

53. The House from the Garden

About 1922
Oil on canvas; 35 1/16 × 39 3/8 in. (89 × 100 cm.)
Collection of the Musée Marmottan, Paris (5103)

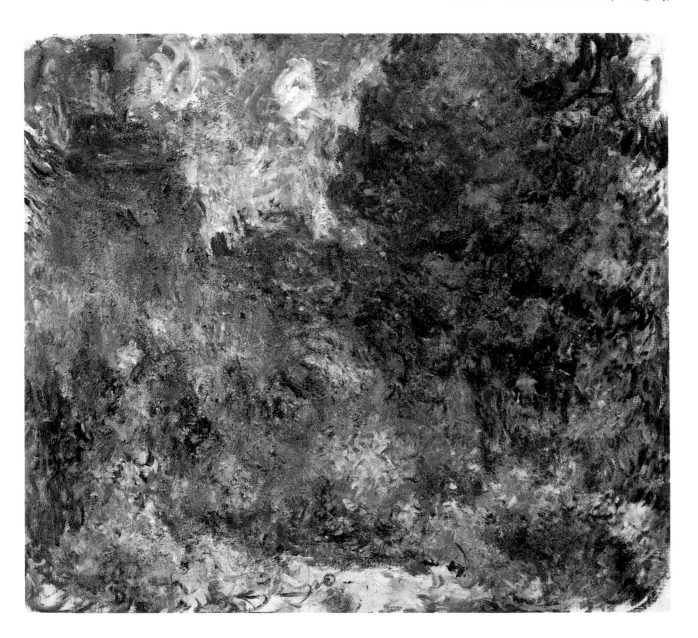

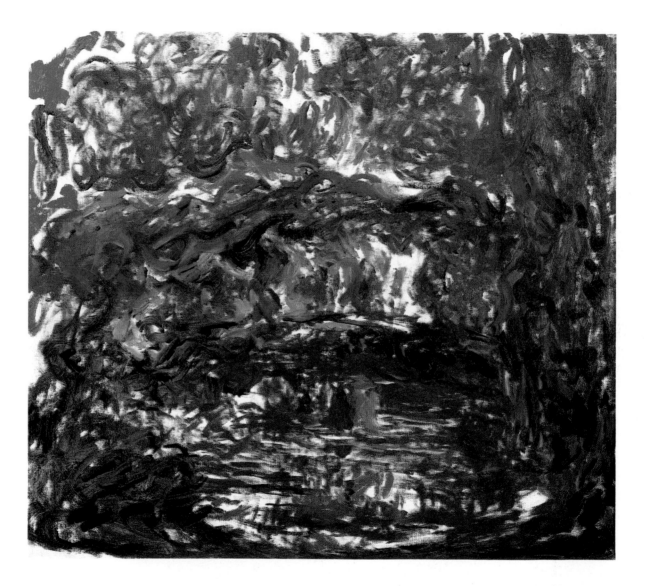

54. The Japanese Footbridge at Giverny

About 1923
Oil on canvas; 35⅟₁₆ × 39⅜ in. (89 × 100 cm.)
Collection of the Musée Marmottan, Paris (5093)

55. The Japanese Footbridge at Giverny

About 1923
Stamped, upper left: *Claude Monet*
Oil on canvas; 35 × 36¾ in. (88.9 × 93.3 cm.)
The Museum of Fine Arts, Houston
John A. and Audrey Jones Beck Collection (76.198)

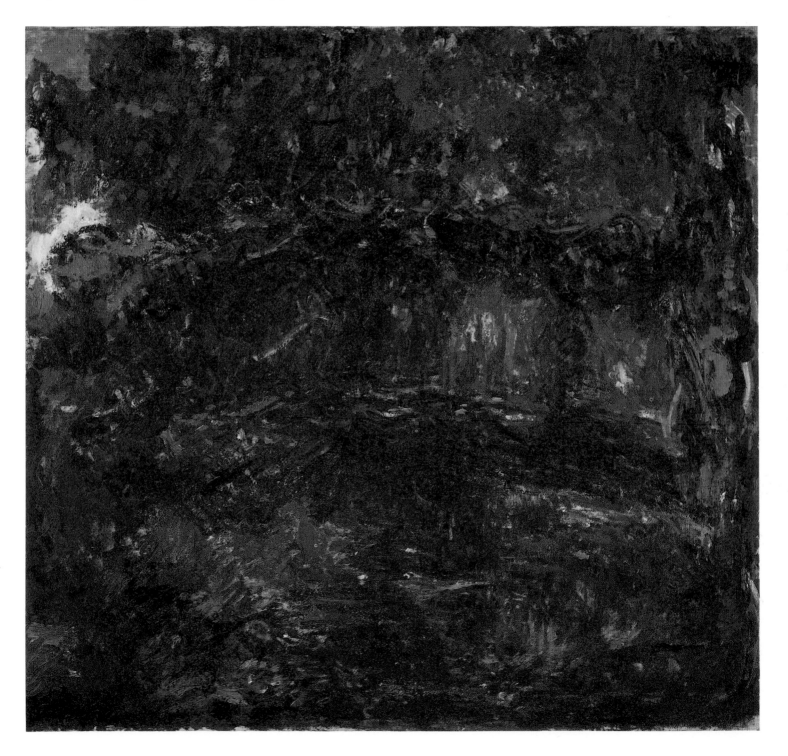

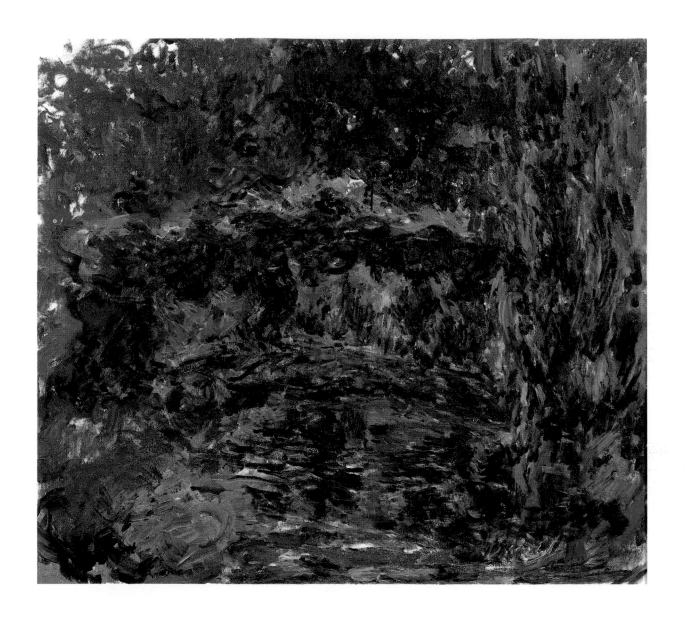

56. The Japanese Footbridge at Giverny

About 1923
Oil on canvas; 35 1/16 × 39 3/8 in. (89 × 100 cm.)
Collection of the Musée Marmottan, Paris (5091)

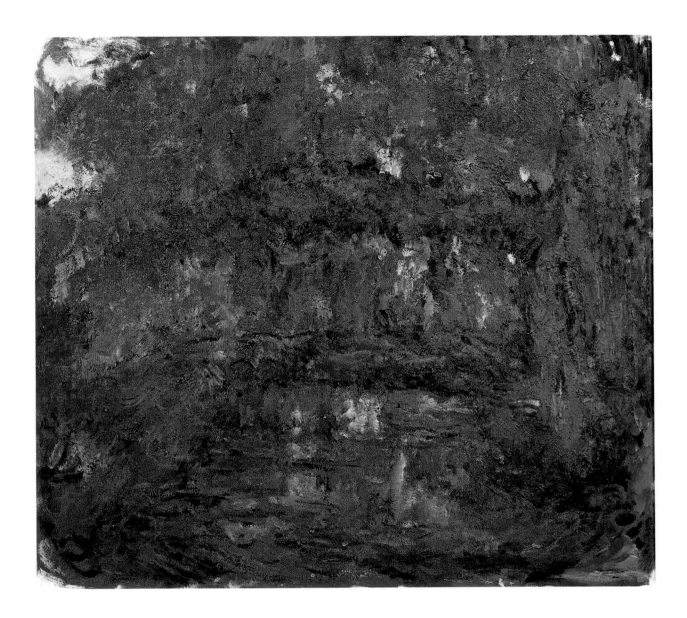

57. The Japanese Footbridge at Giverny

About 1923
Oil on canvas; 35 1/16 × 39 3/8 in. (89 × 100 cm.)
Collection of the Musée Marmottan, Paris (5092)

OVERLEAF:

58. The Bridge over the Water Lily Pond

About 1923
Stamped, lower right: *Claude Monet*
Oil on canvas; 39 3/8 × 78 3/4 in. (100 × 200 cm.)
Collection of the Musée Marmottan, Paris (5077)

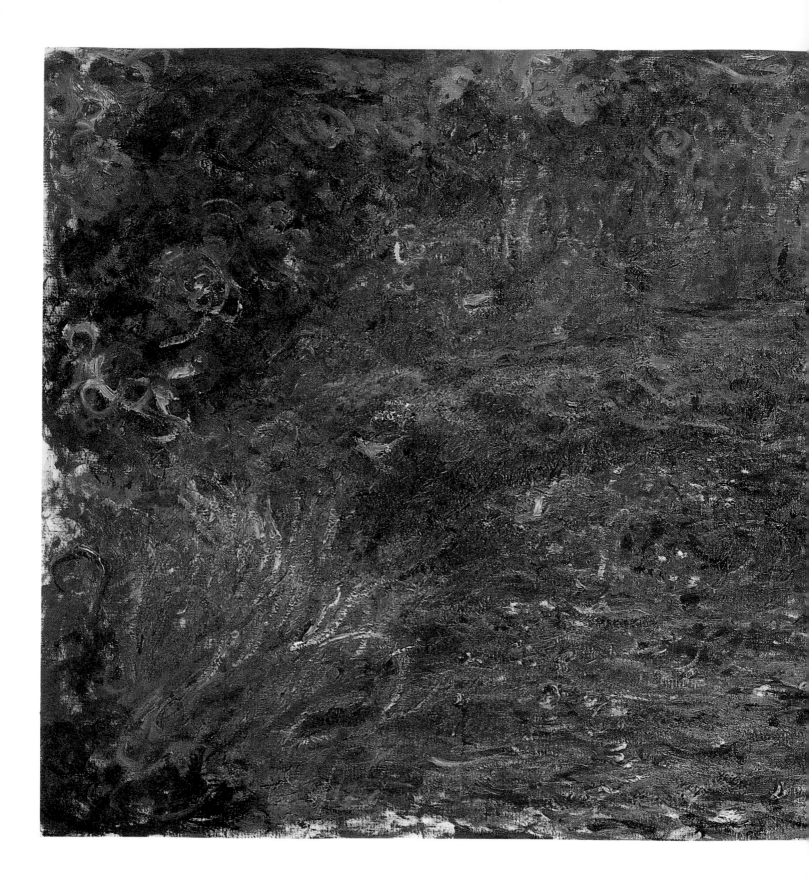

POND SUBJECTS

59. The Roses

About 1920 (?)
Oil on canvas; 51¾₁₆ × 78¾ in. (130 × 200 cm.)
Collection of the Musée Marmottan, Paris (5096)

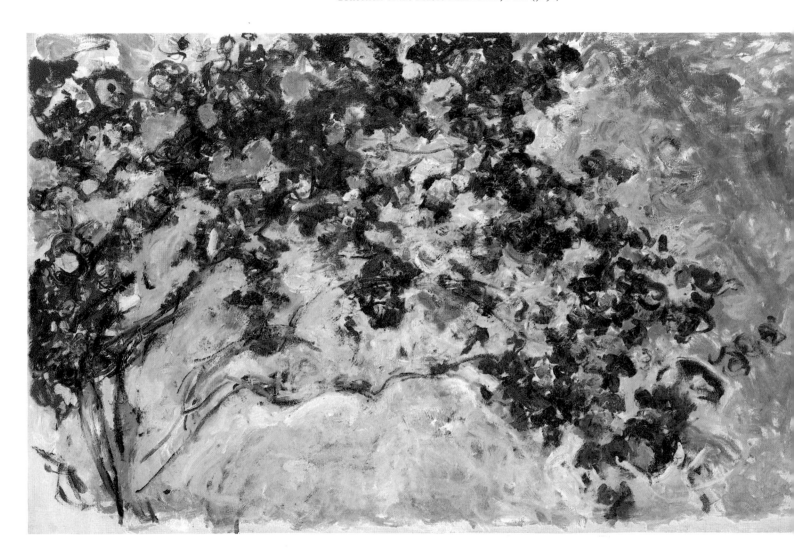

60. The Irises

About 1918–1925
Stamped, lower left: *Claude Monet*
Oil on canvas; 41¾ × 61 in. (106 × 154.9 cm.)
Collection of the Musée Marmottan, Paris (5083)

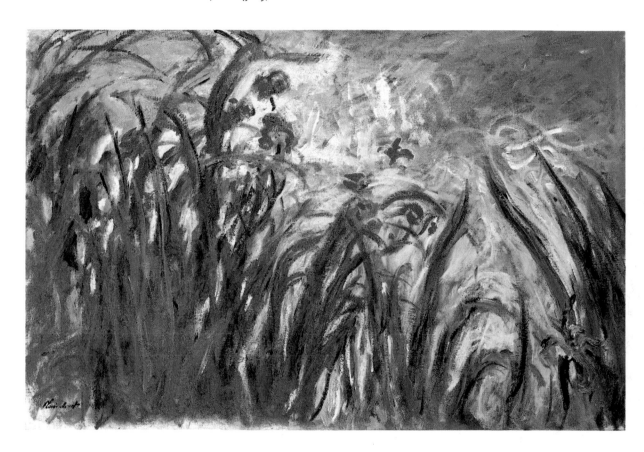

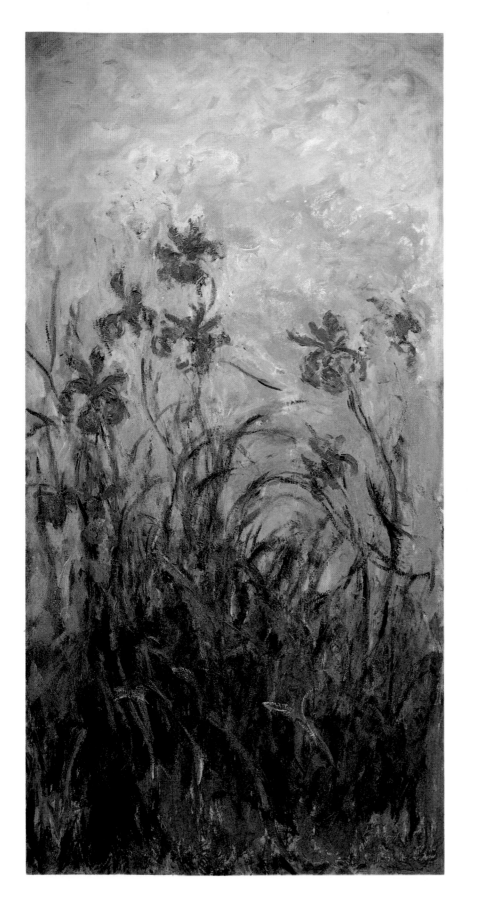

61. Irises

About 1918–1925
Stamped, lower right: *Claude Monet*
Oil on canvas; 79 × 39½ in. (200.7 × 100.3 cm.)
Lent anonymously

62. Iris

About 1918–1925
Stamped, lower right: *Claude Monet*
Oil on canvas; 78¾ × 59 in. (200 × 149.9 cm.)
Galerie Beyeler, Basel

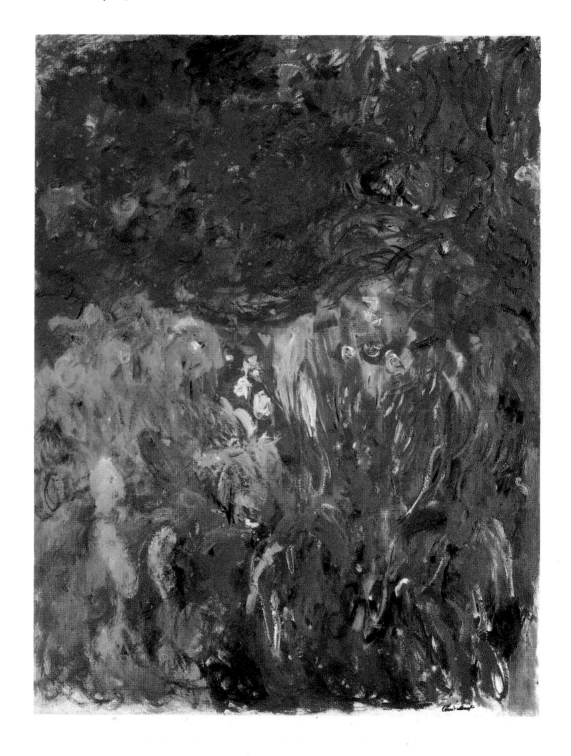

63. Irises by the Pond

About 1918–1925
Stamped, lower left: *Claude Monet*
Oil on canvas; 78½ × 59¼ in. (199.4 × 150.5 cm.)
Virginia Museum of Fine Arts, Richmond

64. The Path through the Irises

About 1918–1925
Stamped, lower right: *Claude Monet*
Oil on canvas; 78¾ × 70⅞ in. (200 × 180 cm.)
Collection of the Honorable and Mrs. Walter H. Annenberg

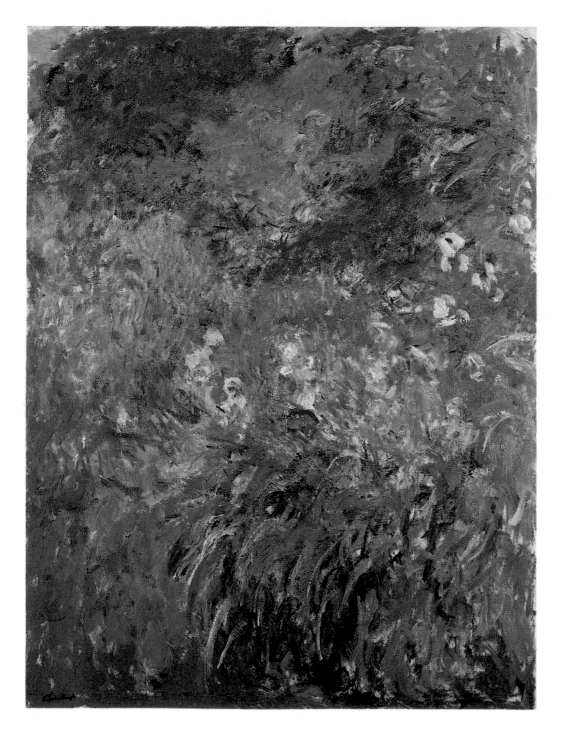

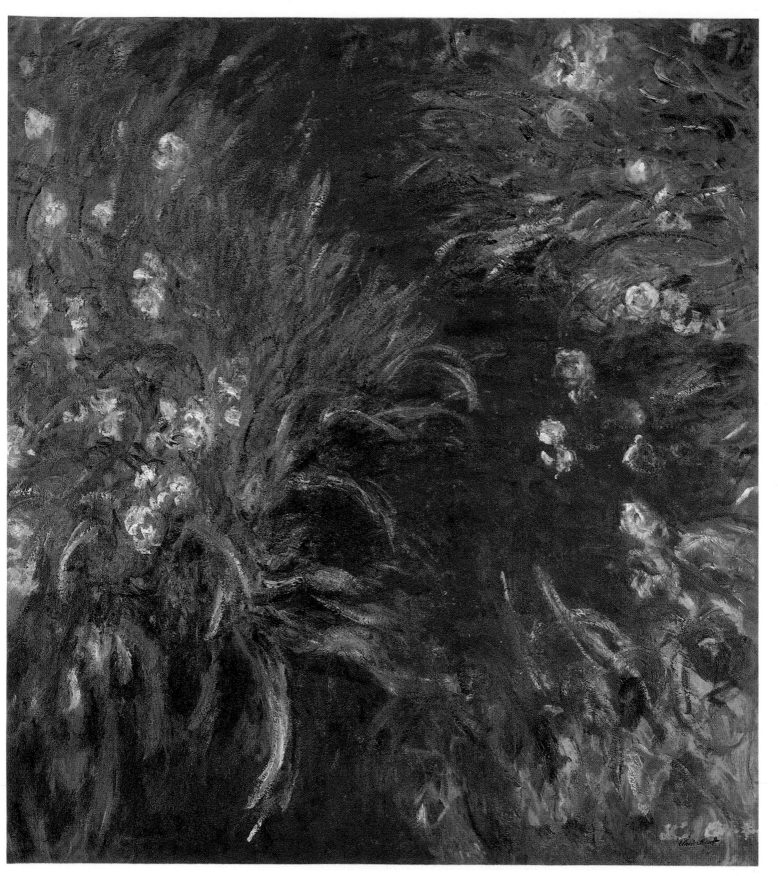

66. Agapanthus

About 1918–1925
Oil on canvas; 78¾ × 70⅞ in. (200 × 180 cm.)
Collection of Mr. and Mrs. Joseph Slifka

65. Flowers by the Pond

About 1918–1925
Labeled, on stretcher: *M. Claude Monet, à Giverny*
Oil on canvas; 59⅟₁₆ × 55½ in. (150 × 141 cm.)
Collection of the Musée Marmottan, Paris

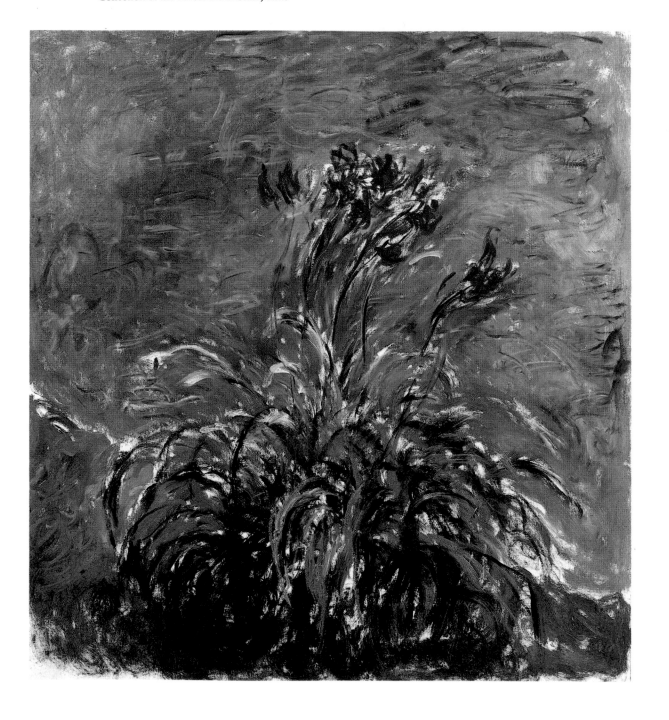

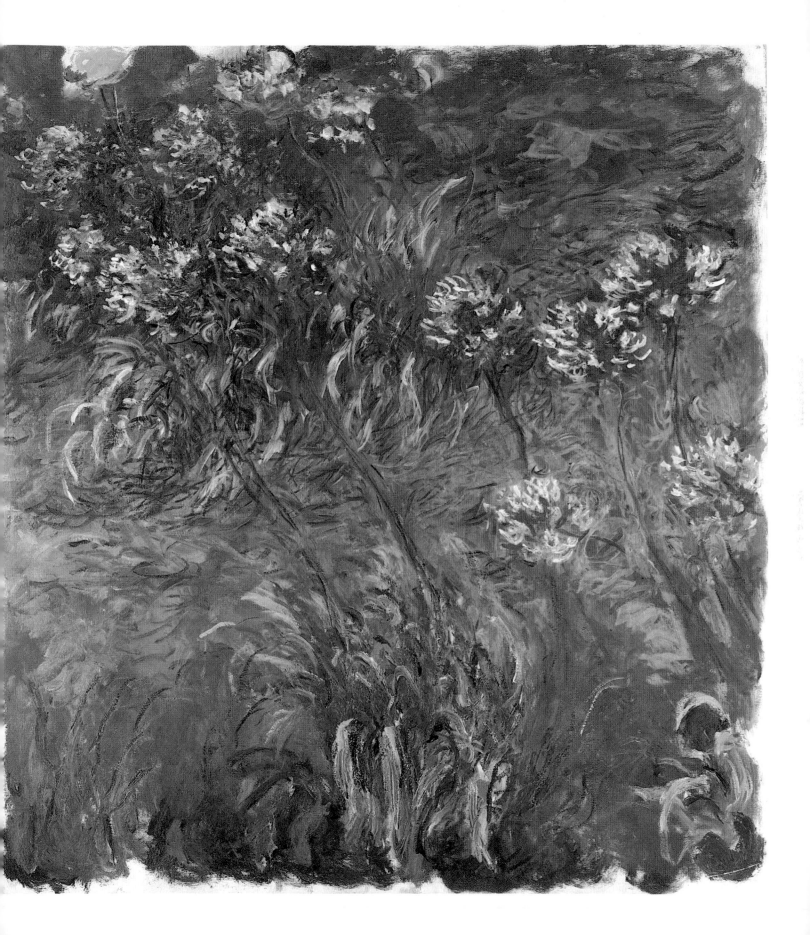

67. Weeping Willow

About 1919
Oil on canvas; 39 × 47¼ in. (99.1 × 120 cm.)
Collection of the Musée Marmottan, Paris (5080)

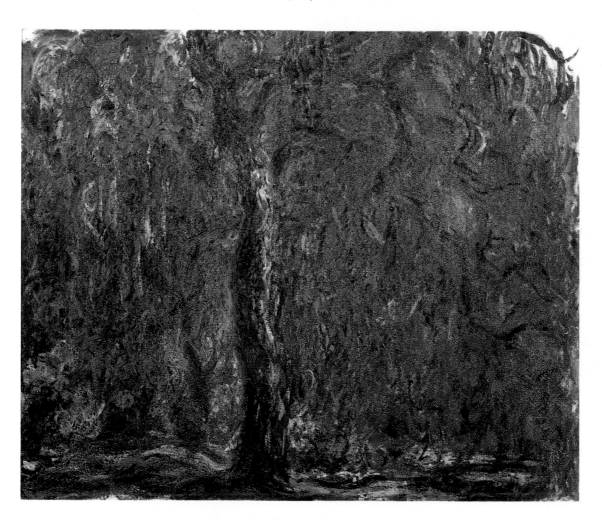

68. Water Lilies

About 1918–1925
Oil on canvas; 78¾ × 70⅞ in. (200 × 180 cm.)
Collection of the Musée Marmottan, Paris (5117)

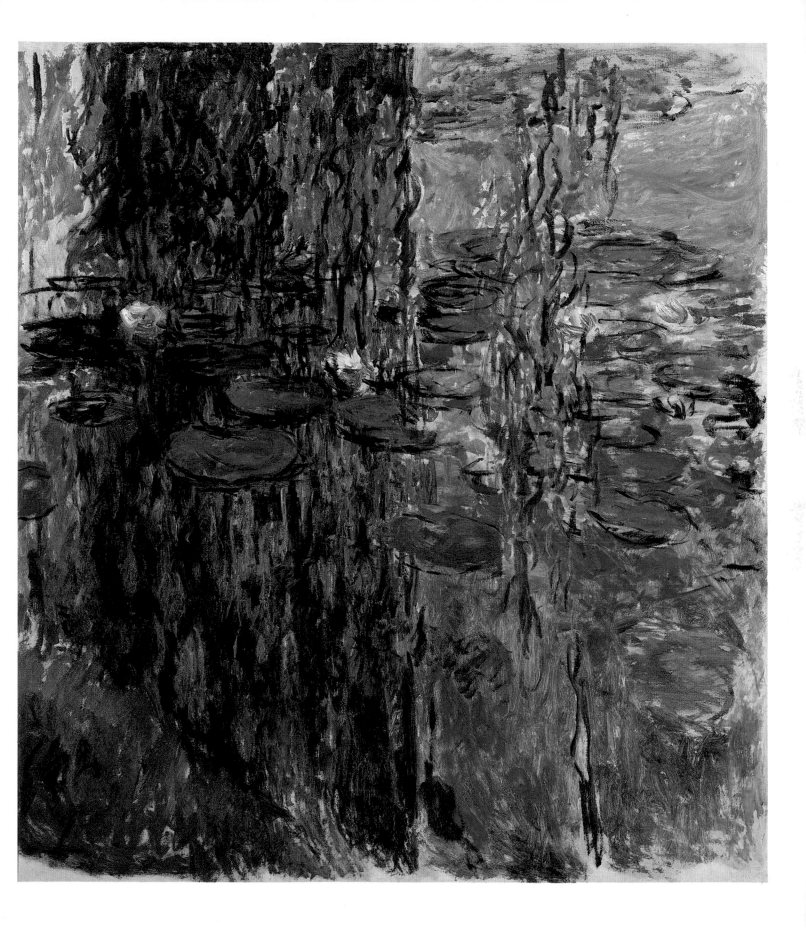

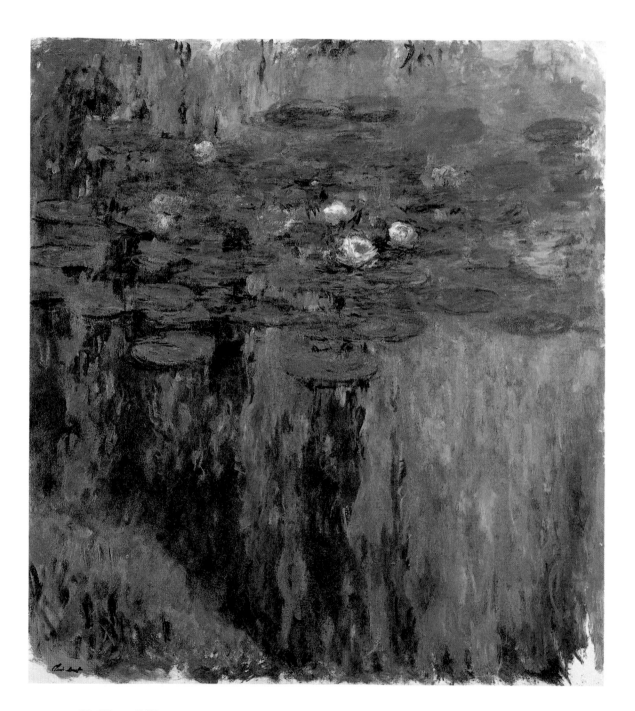

69. Water Lilies

About 1918–1925
Stamped, lower left: *Claude Monet*
Oil on canvas; 78¾ × 78¾ in. (200 × 200 cm.)
Collection of the Musée Marmottan, Paris (5119)

70. Water Lilies—Reflections of the Willo

About 1918–1925
Oil on canvas; 78¾ × 79⅛ in. (200 × 201 cm.)
Collection of the Musée Marmottan, Paris (5122)

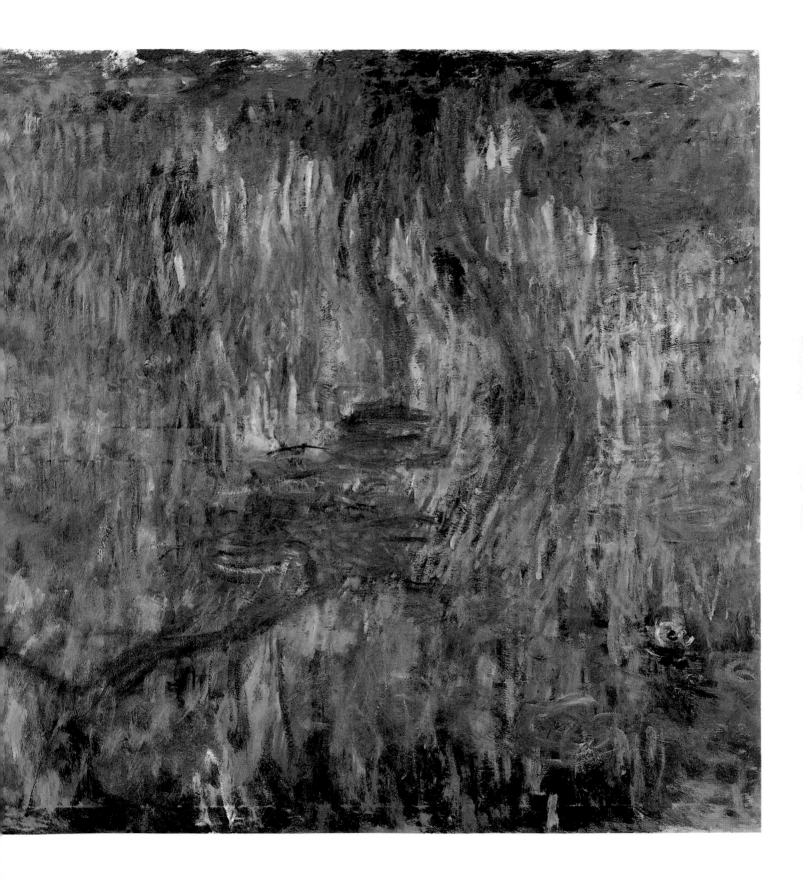

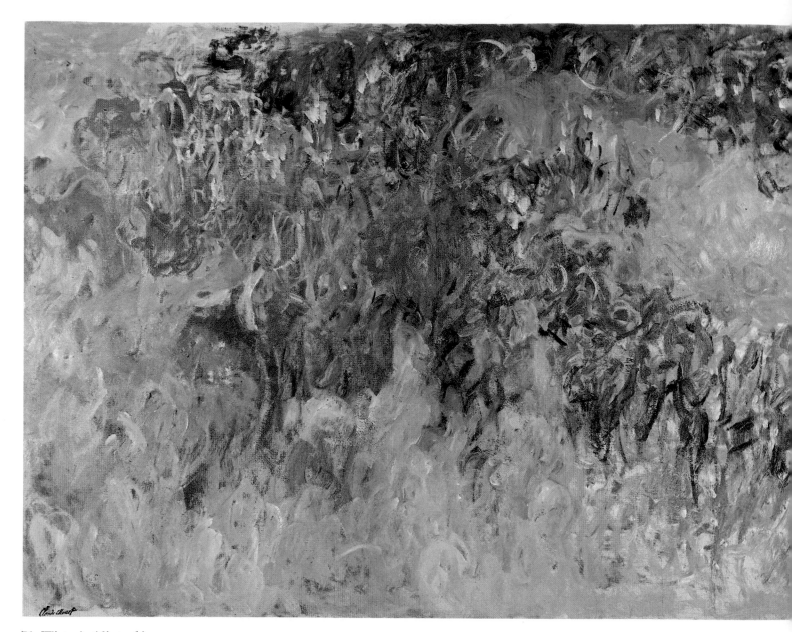

71. Wisteria (diptych)

About 1920
Left panel stamped, lower left: *Claude Monet*
Right panel stamped, lower right: *Claude Monet*
Oil on canvas; 59¹⁄₁₆ × 78¾ in. (each panel) (150 × 200 cm.)
Collection of Mr. and Mrs. Joseph Pulitzer, Jr.

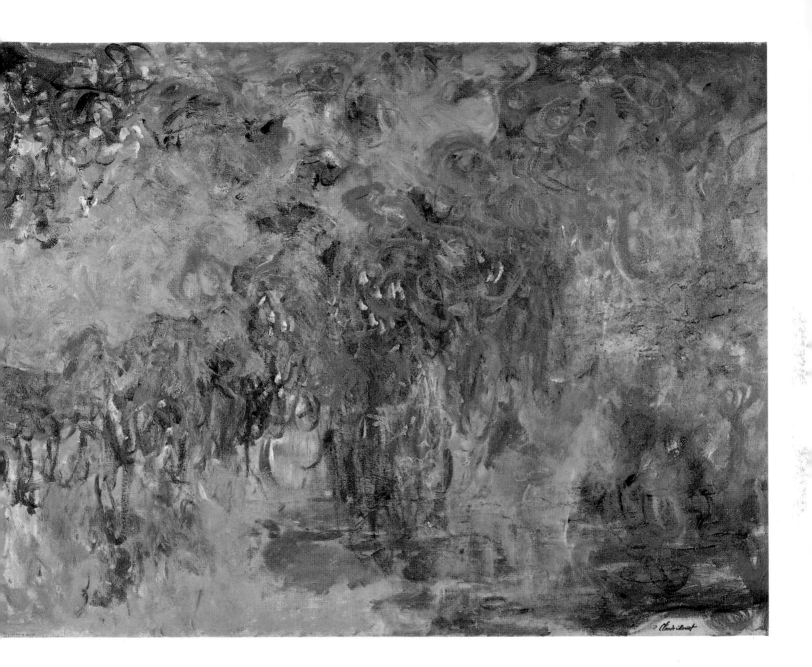

72. Wisteria

About 1920 (?)
Labeled on stretcher: *Monsieur Claude Monet, Gare Vernon—Eure*
Oil on canvas; 39⅜ × 118½ in. (100 × 301 cm.)
Collection of the Musée Marmottan, Paris (5123)

73. Wisteria

About 1920 (?)
Oil on canvas; 39⅜ × 118½ in. (100 × 301 cm.)
Collection of the Musée Marmottan, Paris (5124)

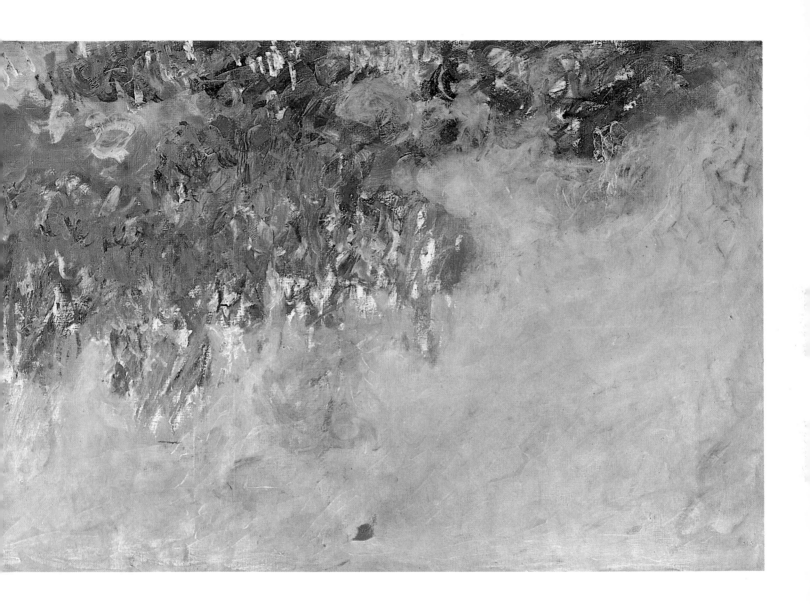

LATE WATER LILIES

74. Water Lilies

About 1920
Oil on canvas; 78¾ × 79⅛ in. (200 × 201 cm.)
Collection of the Musée Marmottan, Paris (5115)

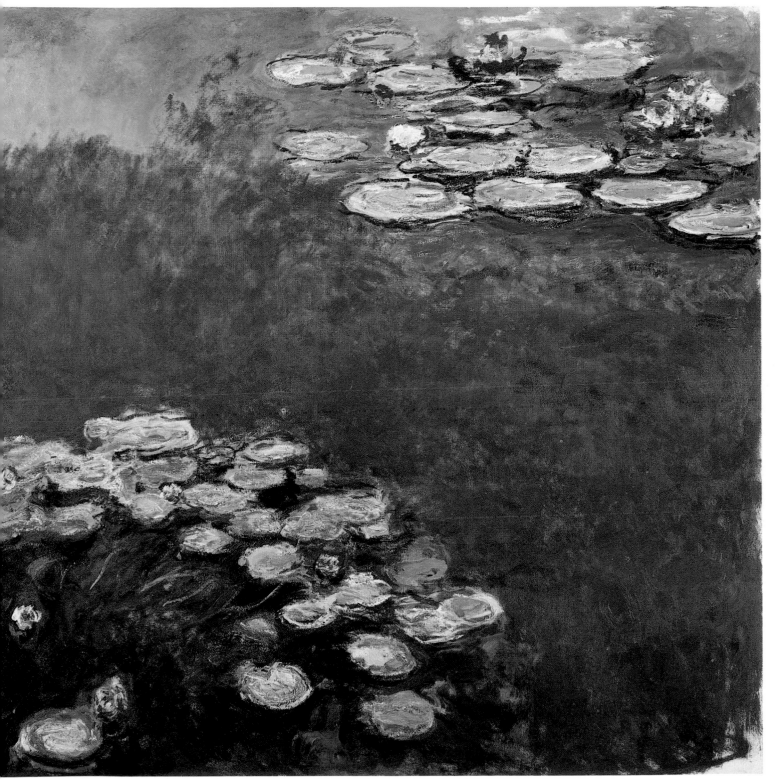

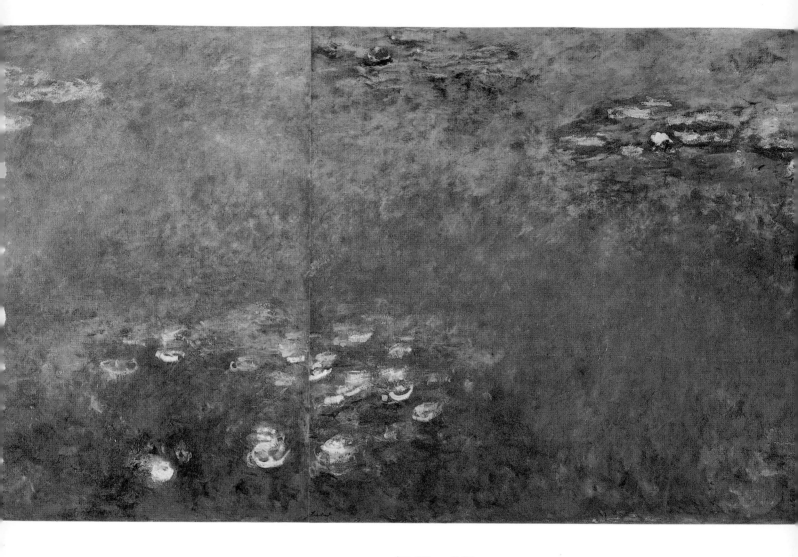

77. Water Lilies

About 1919–1926
Stamped, lower left: *Claude Monet*
Oil on canvas; 78¾ × 167¾ in. (200 × 426.1 cm.)
The St. Louis Art Museum
Gift of the Steinberg Charitable Fund (134:1956)

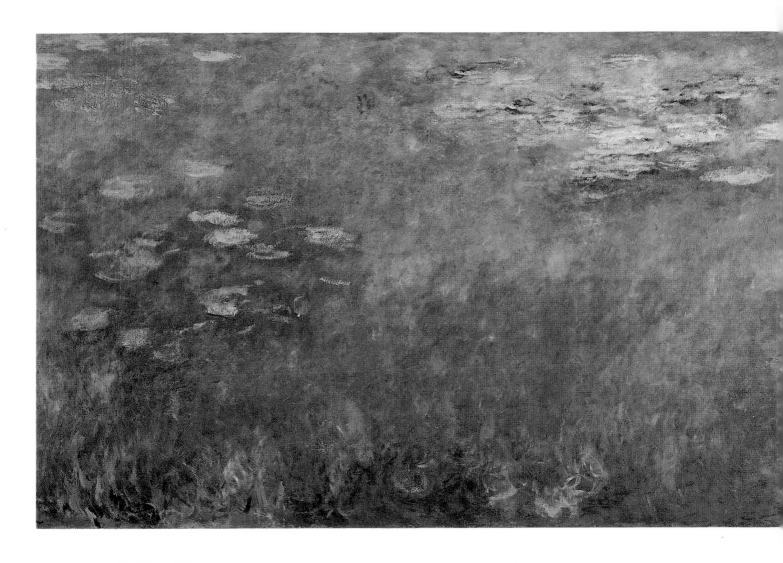

76. Water Lilies

About 1919–1926
Stamped, lower left: *Claude Monet*
Oil on canvas; 78¾ × 167¾ in. (200 × 426.1 cm.)
The Cleveland Museum of Art
Purchase, John L. Severance Fund (60.81)

OVERLEAF:
75. Water Lilies

Signed and dated, lower left: *Claude Monet 1919*
Oil on canvas; 40 × 80 in. (101.6 × 203.2 cm.)
Collection of the Honorable and Mrs. Walter H. Annenberg

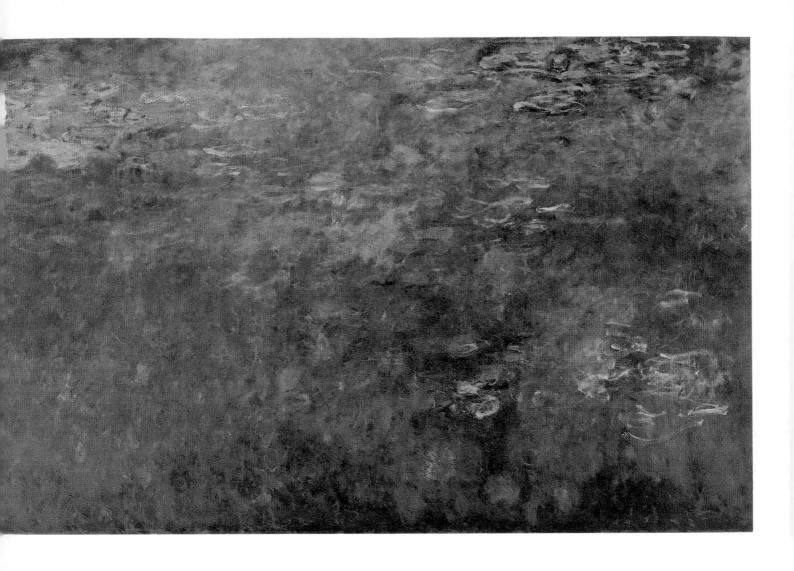

cm.)
rt-Atkins Museum

vere separated
5os. They are

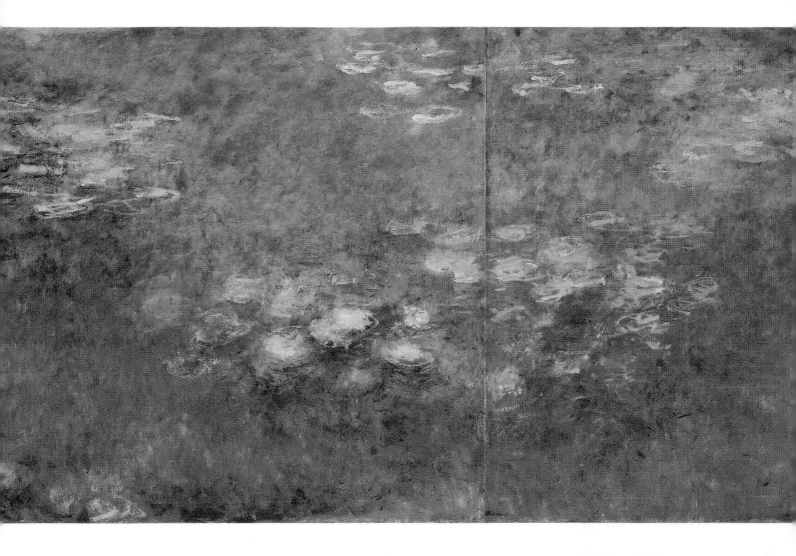

78. Water Lilies

About 1919–1926
Stamped, lower left: *Claude Monet*
Oil on canvas; 78¾ × 167¾ in. (200 × 426.
The William Rockhill Nelson Gallery of /
 of Fine Arts, Kansas City, Missouri
Nelson Fund (57.26)

These three panels, forming a triptych,
and sold individually, probably in the 1₀
exhibited here together for the first time.

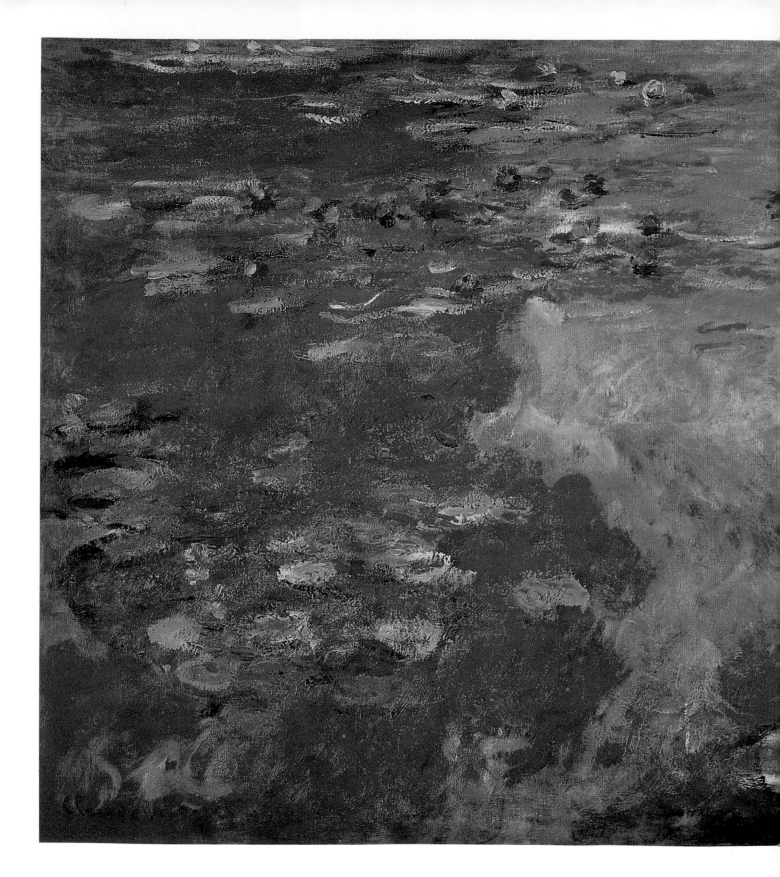

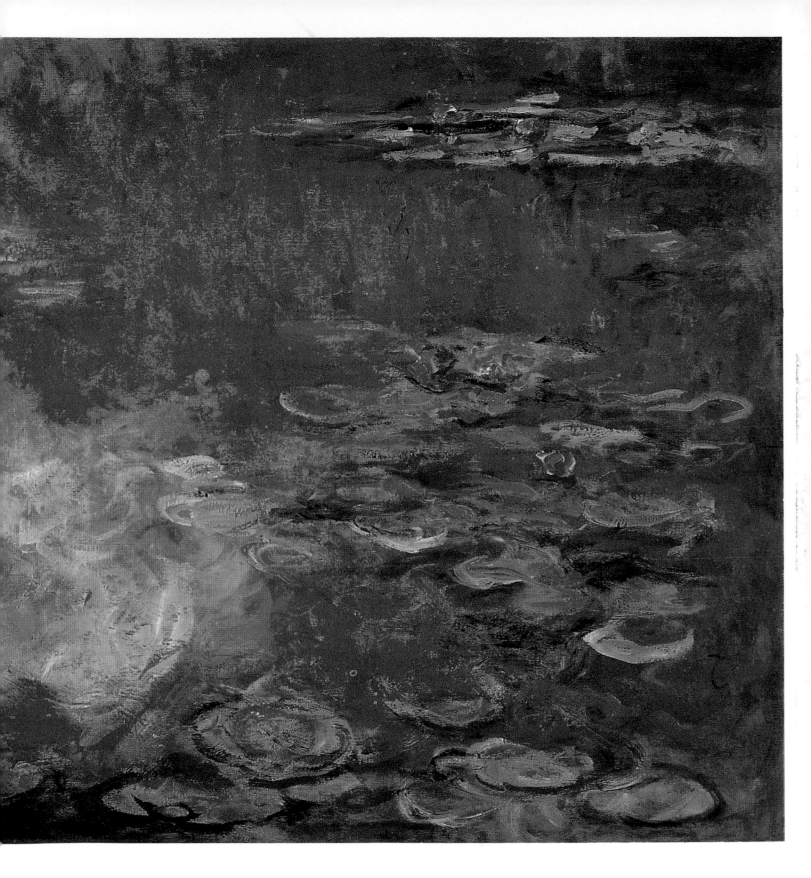

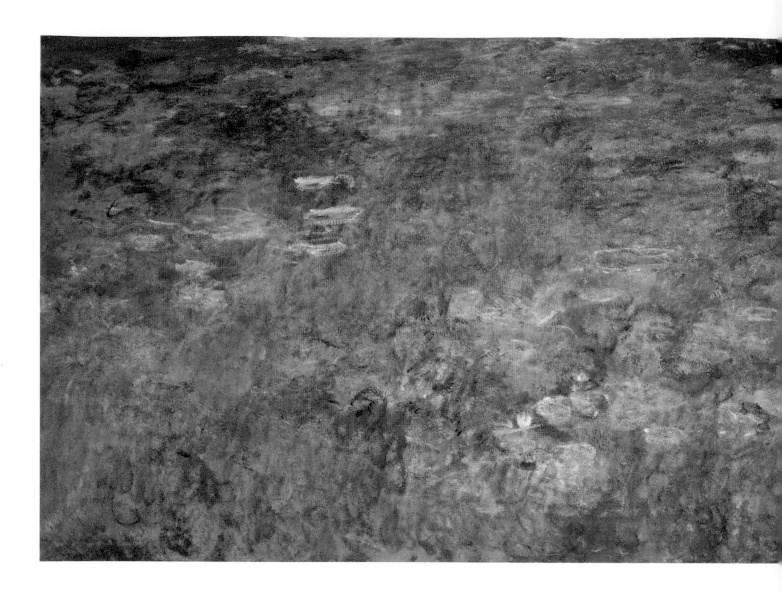

79. Water Lilies (triptych)

About 1916–1923
Each panel stamped on reverse, upper right: *Claude Monet*
Oil on canvas; 78¾ × 118¼ in. (each panel) (200 × 300.4 cm.)
Collection of Ernst Beyeler, Basel

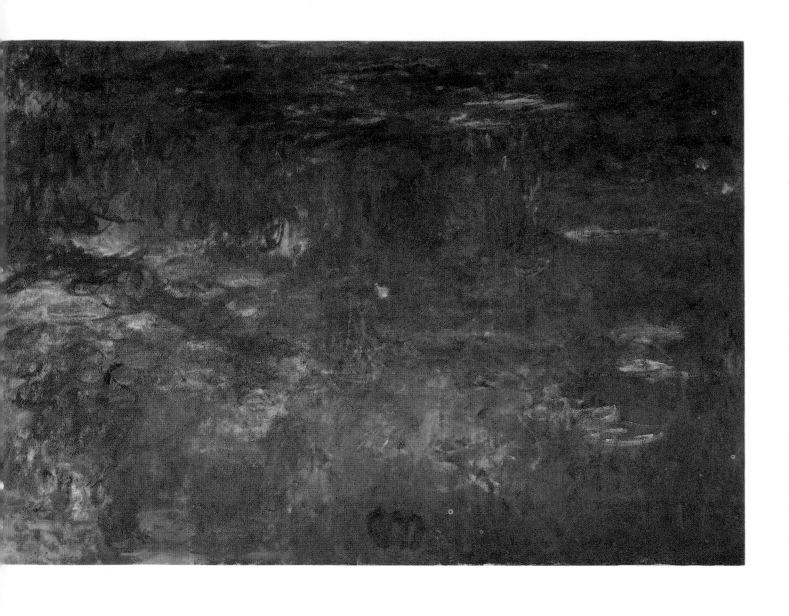

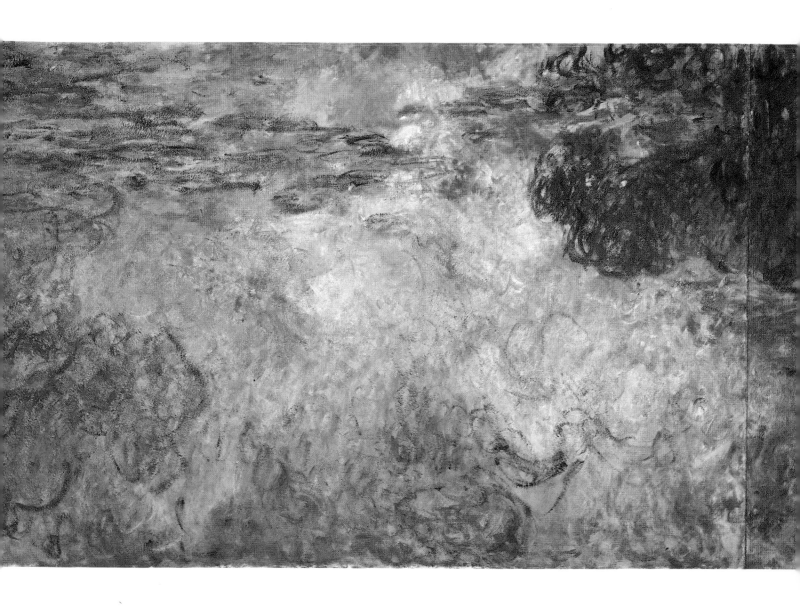

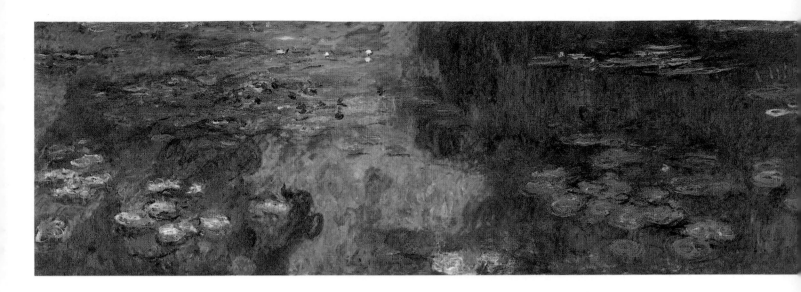

80. Water Lilies

About 1920–1921
Oil on canvas; 78 × 235 in. (198.1 × 596.9 cm.)
Museum of Art, Carnegie Institute, Pittsburgh
Acquired through the generosity of Mrs. Alan M. Scaife
 (62.19.1)

81. Water Lilies

About 1920 (?)
Oil on canvas; 39⅜ × 118⅛ in. (100 × 300 cm.)
Collection of the Musée Marmottan, Paris (5118)

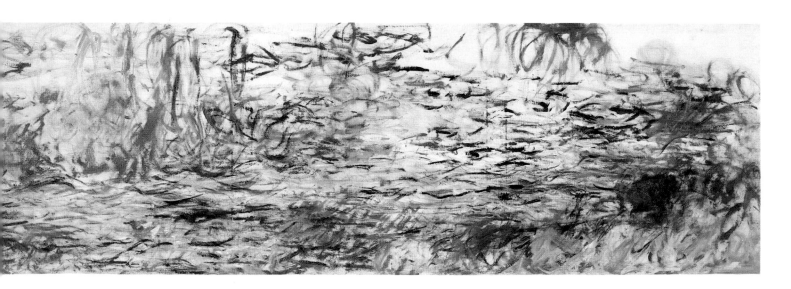

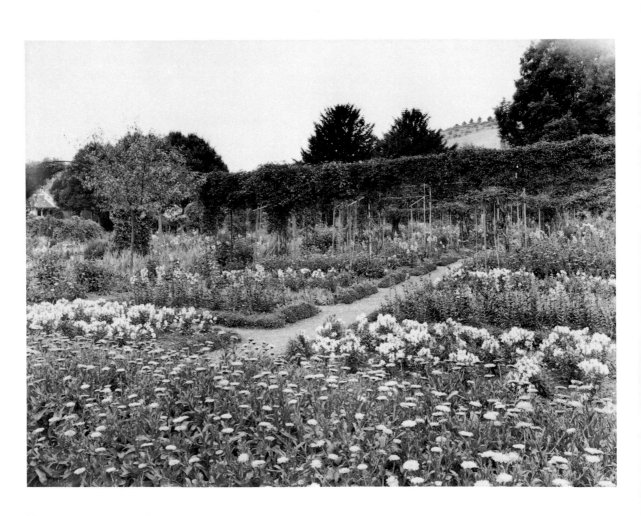

The flower garden, about 1933

Collection of *Country Life* Magazine, London

Chronology

1883

The Church at Vernon, No. 1

January–February	Monet paints in Normandy, at Le Havre, then at Étretat.
March 1–25	Exhibition: one-man retrospective of fifty-six paintings of the Normandy coast is held at Durand-Ruel Gallery, Paris. This is one in a series of Impressionist one-man exhibitions organized by Paul Durand-Ruel. Some critical response is favorable; sales are low.
April 21	Exhibition: group Impressionist show opens at Dowdeswell and Dowdeswell Gallery, London, includes seven Monets priced between 100 and 160 pounds.
April 30	Monet leases a house, which he buys seven years later, in Giverny in the district known as Le Pressoir. He moves there from Poissy with his companion, Alice Hoschedé, and their respective children. The families had been close since 1876; the following year Alice was abandoned by her husband, ruined businessman and art patron Ernest Hoschedé.
	Édouard Manet dies; Monet is a pallbearer at the funeral in Paris on May 3.
Spring–summer	Monet paints in nearby Vernon and begins planting his garden.
July	Monet is commissioned to paint floral decorations for Durand-Ruel's Paris apartment.
Late October	Monet visits his brother Léon and Camille Pissarro in Rouen.
December 10–26	Monet travels with Auguste Renoir to Genoa and the Riviera; they visit Paul Cézanne at l'Estaque.

1884

Autumn on the Seine, No. 2
Banks of the Seine at Jeufosse, Autumn, No. 3

Durand-Ruel, along with other art dealers, is in financial difficulty.

1884, continued

Salon des Indépendants is founded in Paris.

Société des Vingt is founded in Brussels.

Late January–March Monet returns without Renoir to the Riviera and paints at Bordighera, Dolce Acqua, and Ventimiglia.

April Monet paints at Menton.

August Monet paints at Étretat again.

Fall Monet paints along the Seine near Giverny.

1885

The Seine at Giverny, No. 4
Poppy Field in a Hollow near Giverny, No. 5

May Exhibition: ten works by Monet are in the fourth Exposition International at the fashionable Georges Petit Gallery, Paris, a rival firm of Durand-Ruel.

Early October–December Monet again paints at Étretat after a short trip to Rouen.

1886

Spring at Giverny, No. 6

Émile Zola publishes his novel *L'Oeuvre*, which alienates the Impressionists, since it seems to be a pastiche from the lives of several of them, including Manet, Cézanne, and Monet.

Monet and Renoir meet poet Stéphane Mallarmé through Berthe Morisot.

Sales of Monet's work increase and critical response improves.

When possible, Monet attends the Impressionists' monthly dinners at the Café Riche with Pissarro, Théodore Duret, Renoir, Mallarmé, Joris-Karl Huysmans, and others.

Late April–May	Monet visits Holland for the third time, stopping at Haarlem, The Hague, and other cities.
April 10–late May	Exhibition: large Impressionist show is mounted at the American Art Association, New York. Organized by Durand-Ruel, it includes fifty works by Monet. This is Durand-Ruel's first success in America; Monet disapproves of the American venture. On May 25 the exhibition moves to the National Academy of Design, New York.
Spring	Exhibition: ten works by Monet are shown with the Société des Vingt in Brussels.
May 15–June 15	Eighth and last Impressionist group exhibition. Monet does not participate. Georges Seurat exhibits La Grande Jatte.
Early summer	Exhibition: thirteen (?) of Monet's recent works are in the fifth Exposition International at the Georges Petit Gallery, Paris. Renoir is also represented.
Summer	Monet paints figures outdoors.
Early September–November	Monet revisits Étretat and paints at Belle-Ile, where he meets Gustave Geffroy, art critic for statesman Georges Clemenceau's journal *La Justice* and Monet's future biographer.
Late November	Monet spends a short time with Octave Mirbeau on the island of Noirmoutier.

1887

The Boat, No. 7

	Durand-Ruel opens a gallery in a New York mansion owned by collector H. O. Havemeyer.
	Pissarro is interested in the new theories of the Neo-Impressionists.
May	Exhibition: fifteen works, including ten Belle-Ile views, are shown at the sixth Exposition International at the Georges Petit Gallery, Paris, with great success. Renoir, Pissarro, Alfred Sisley, and Morisot also exhibit.
May–June	Exhibition: Monet shows at Durand-Ruel's second Impressionist exhibition at the National Academy of Design, New York.
December	Exhibition: two of Monet's paintings are shown by the Royal Society of British Artists, London.

The first studio, about 1905–1906

The Museum of Modern Art, New York

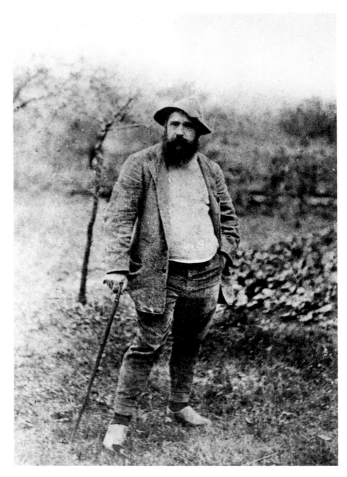

Monet at forty-nine, six years after arriving at Giverny,
1889. By Theodore Robinson

From the archives of the Fondation Wildenstein, Paris

1888

Morning Landscape, No. 8
A Bend in the Epte River, near Giverny, No. 9
The Meadow at Giverny, No. 10

January–April Monet paints in Antibes and at nearby Juan-les-Pins on the Riviera.

Spring Monet refuses to exhibit with Renoir, Pissarro, and Sisley in Durand-Ruel's group show.

June Exhibition: ten of Monet's Antibes landscapes are shown alone at the Boussod and Valadon Gallery, Paris, with which Monet continues to deal. The show is a great success, praised by many, including Mallarmé. Theo van Gogh, manager of the gallery, has apparently been buying works by Monet and other Impressionists for some time. This exhibition, as well as Monet's dealings with Georges Petit, adds to his difficulties with Durand-Ruel.

July Monet visits London.

He refuses the Legion of Honor from the French government.

Summer Monet paints in Giverny, possibly with John Singer Sargent.

Late fall He begins the Haystacks series.

1889

January Monet visits Maurice Rollinat at Fresselines, in Creuse, with Geffroy.

February Exhibition: Monet again shows at the Boussod and Valadon Gallery, Paris.

March–May Monet returns to Fresselines to paint.

Spring Exhibition: twenty works by Monet are shown at the Goupil Gallery, London.

Exhibition: Monet again shows with the Société des Vingt, Brussels.

June Exhibition: with Rodin, Monet organizes a very successful joint retrospective at the Georges Petit Gallery, Paris. Octave Mirbeau writes the preface to the catalogue, which includes 145 works.

October 12 A record price of 10,350 francs is obtained by Theo van Gogh for a painting by Monet.

Fall Monet organizes a subscription to buy Manet's Olympia for presentation to the state.

1890

Field of Poppies, No. 21
The Oat Field, No. 22
Haystacks at Noon, No. 11

Monet continues work on the Haystacks series, partly in the studio.

Having terminated his arrangement with Boussod and Valadon, he is again represented by Durand-Ruel, but not on an exclusive basis.

Vincent van Gogh dies at thirty-seven.

November — Monet buys the house and property at Giverny.

Manet's Olympia, offered to the state in February, is officially accepted.

1891

Haystacks in the Snow, No. 12
Haystacks, Setting Sun, No. 13
Haystack at Sunset, No. 14
Two Haystacks, No. 15
Poplars, Nos. 16–18
Pink Poplars, No. 19
Poplars in the Sun, No. 20

Seurat dies at thirty-two; Arthur Rimbaud dies at thirty-seven.

January — Monet paints ice floating on the Seine.

May — Exhibition: twenty-two paintings—including two fields of flowers, two Oat Fields, and, separately, fifteen of the Haystacks series—are shown at Durand-Ruel's Paris gallery. Gustave Geffroy writes the preface to the catalogue. The show is a huge success, with prices ranging between 3,000 and 4,000 francs. All paintings are sold within four days. Monet now commands the highest prices of the Impressionists.

Spring–summer — Monet begins painting the Poplars series.

Monet is forced to buy a row of poplars from the town of Limetz in order to continue painting them.

December	Monet visits London. On Christmas Day he writes Durand-Ruel that he would like to paint there again.

1892

	Monet builds greenhouses on his Giverny property and continues work on his garden. He hires six gardeners.
February 29–March 10	Exhibition: fifteen paintings from the Poplars series are shown at Durand-Ruel's Paris gallery. The exhibition is highly successful.
Late February–April	Monet begins painting the Rouen Cathedral series from the second-floor window at 81 rue du Grand-Pont.
	On April 13 he writes Durand-Ruel of his discouragement with the project.
July 16	Monet marries Alice Hoschedé, widow of Ernest Hoschedé. It is Monet's second marriage.
July 20	Suzanne Hoschedé, Monet's stepdaughter, marries Theodore Butler, an American painter.

1893

The Ice Floe, No. 23
Haystack in Field, No. 24

	Works by Monet and other Impressionists are exhibited in a show of foreign masters from American collections at the Chicago World's Fair.
	The Société des Vingt in Brussels is dissolved.
	With Mirbeau and stepdaughter Blanche, Monet takes a cruise on the liner Normandie to Cherbourg to witness the visit of Tsar Alexander III.
Winter	Monet paints ice on the Seine at Bennecourt.
February–April	He returns to Rouen to continue with the Cathedral series, at times becoming discouraged. He works on these in his studio at Giverny throughout the year.

157

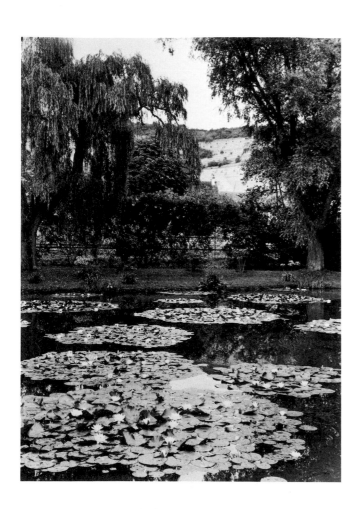

View toward Monet's house from the water-lily pond, about 1933

Collection of *Country Life* Magazine, London

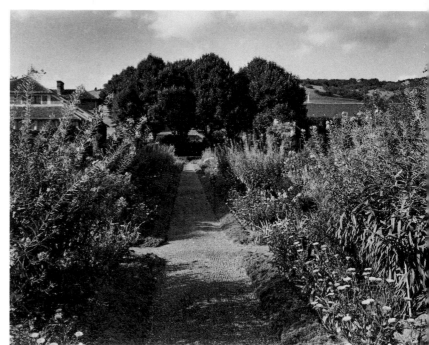

The garden, with the second studio at left
About 1933

Collection of *Country Life* Magazine, London

1893, continued

February 5 Monet purchases a tract of land, containing a stream and a pond, across from his home. He begins work on the pond. Later he builds the Japanese footbridge over it.

1894

Monet continues work on the Cathedral series.

The Dreyfus Affair begins (Monet is pro-Dreyfus).

Monet's stepdaughter Suzanne's paralysis begins.

March 2 Gustave Caillebotte dies, leaving sixty-seven Impressionist paintings to the state. The bequest includes sixteen Monets, eight of which are ultimately accepted.

November Cézanne visits and paints with Monet in Giverny, staying in the Hotel Baudy. He meets Auguste Rodin, Geffroy, Clemenceau, and others.

1895

Kandinsky sees one of Monet's Haystacks in an exhibition in Moscow.

Late January–early April Monet visits his stepson in Norway, stays in the village of Sandviken on the slopes of Mount Kolsaas, near Oslo, and paints these sites, as well as other subjects.

Spring Monet begins painting the Japanese footbridge.

May 10–31 Exhibition: twenty of the more than forty paintings in the Cathedral series and about thirty other recent works are shown at Durand-Ruel's gallery in Paris. The show is highly successful; the Cathedrals sell rapidly at the very high price of 15,000 francs each.

June Monet travels to Sailies-de-Béarn in the Pyrenees for a rest cure with his family.

1896

Fourteen paintings in the Cathedral series are exhibited in New York.

Monet continues pro-Dreyfus activities.

1896, continued

He begins the Morning on the Seine series near Giverny.

Late February–March Monet paints in Pourville, Dieppe, and Varengeville, where he worked fourteen years earlier.

1897

Morning on the Seine, Giverny, No. 25
Morning Mists, No. 26
Branch of the Seine near Giverny II, No. 27
Morning on the Seine, near Giverny, No. 28

Monet's son Jean marries Monet's stepdaughter Blanche Hoschedé. They live in Rouen where Jean works as a chemist for Monet's brother Léon.

Monet has an outbuilding constructed: the ground floor is for the gardeners (later it became the garage and darkroom); the top floor contains apartments for his children and a new studio, the so-called second studio, where he will work during the winter on paintings begun in the spring and summer.

Late January–early April Monet returns to Pourville to paint.

February He participates in an exhibition in Stockholm.

Summer Monet exhibits twenty of the Cathedral paintings in the second Biennale in Venice.

August Maurice Guillemot visits Monet at Giverny. Monet is apparently already thinking of a large decorative cycle of water lilies.

1898

Mallarmé dies.

January 13 Zola publishes "J'Accuse" in Clemenceau's newspaper *L'Aurore*. He is tried for libel and flees to England. Although in agreement with Zola's pro-Dreyfus position, Monet is still estranged from him because of his novel *L'Oeuvre*.

Exhibition: Monet has a major one-man show (his first since 1895) at the Georges Petit Gallery, Paris. Twenty-four paintings done at Pourville, Dieppe, and Varengeville (the Cliffs) are shown, as well as eighteen Morning on the Seine paintings, eight paintings of snow effects done in Norway, four panels of chrysanthemums, and seven of the Rouen Cathedral series paintings (reexhibited).

1899

The Japanese Footbridge and Water Garden, Giverny, No. 29
Water Lilies and Japanese Bridge, No. 30
A Bridge over a Pool of Water Lilies, No. 31
The Japanese Footbridge and the Water Lily Pool, Giverny, No. 32

January 20 Alfred Sisley dies. Monet and his wife go to Paris for the funeral.

February 6 Suzanne Hoschedé Butler, Monet's stepdaughter, dies.

February 14 Suzanne's widower, Theodore Butler, marries her sister Marthe, who has been caring for Suzanne's children since the beginning of her illness in 1894.

April Exhibition: thirty-six of Monet's paintings are included in a group show at the Durand-Ruel Gallery, Paris. Monet also exhibits at the Lotus Club in New York and at Georges Petit's gallery in Paris this year.

Summer Monet works on paintings of the water-lily pond at Giverny, the Japanese Footbridge series (Le Bassin aux nymphéas).

Fall He begins the Thames series in London; stays at the Savoy Hotel.

1900

Pool of Water Lilies, No. 33
The Garden at Giverny, No. 34
The Garden Path, Giverny, No. 35

Monet begins work on paintings of other parts of the garden, including the flower-bordered path leading to the house. He continues painting the water-lily pond, which begins to preoccupy him.

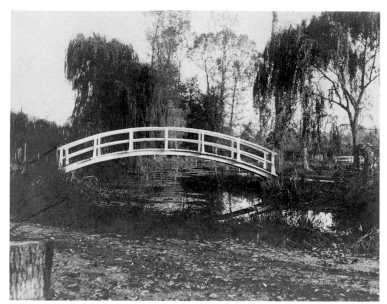

The Japanese footbridge before the trellis was added, before 1901

Collection of the Musée Marmottan, Paris

The path leading from the house to the road and water-lily pond, about 1905–1906

The Museum of Modern Art, New York

February–early April Monet returns to London to work on the Thames series; he is visited there by Clemenceau and Geffroy.

Summer Monet suffers temporary loss of sight in one eye from an accident; is prevented from working for about a month.

mber 22–December 15 Exhibition: twenty-six works in a one-man show at the Durand-Ruel Gallery, Paris, include thirteen (?) paintings from his new Japanese Footbridge (Le Bassin aux nymphéas) series.

Summer–fall Monet again paints river views at Vétheuil.

1901

Monet continues work on his paintings of the Vétheuil area.

Monet purchases about one acre of land near the water-lily pond and begins to enlarge it and grow more exotic plants. He later adds an arched trellis for wisteria above the Japanese footbridge.

Early February–April Monet again returns to London to work on the Thames series. This is apparently the last time he paints in London; he continues work on the London paintings in his studio for several years.

March Sargent visits Monet in London.

November 13 Monet is granted permission to divert a branch of the Epte River through his property.

1902

The Garden Path at Giverny, No. 36

Mary Cassatt reports that Roger Marx tells her, "Monet is painting a series of reflections in water; you see nothing but reflections." Monet has apparently begun the Water Lilies series (the first dated ones are inscribed 1903). These will be exhibited at the Durand-Ruel Gallery, Paris, in 1909.

163

The pond seen through willow branches, about 1933

Collection of *Country Life* Magazine, London

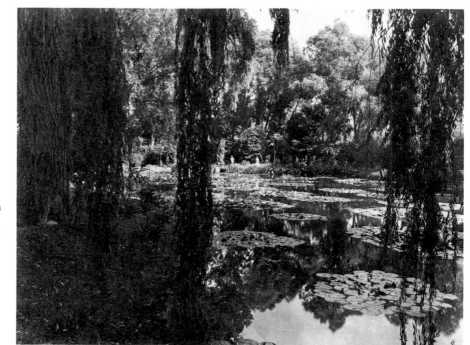

View from the west toward the Japanese footbridge, about 1933

Collection of *Country Life* Magazine, London

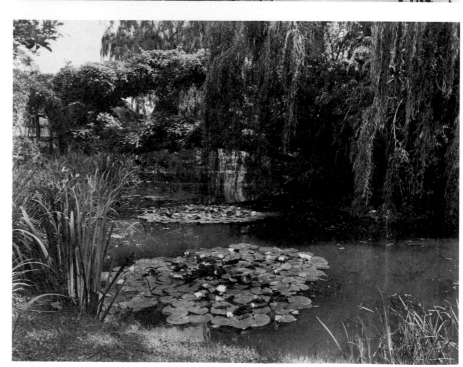

February 21–28 Exhibition: joint show of recent works by Pissarro and Monet is held at the Bernheim-Jeune Gallery, Paris; six paintings of Monet's Vétheuil series are included.

Late February Monet visits Brittany briefly.

November 12 Monet's stepdaughter Germaine Hoschedé marries Albert Salerou, a lawyer from Monaco.

Late fall Monet's son Michel has a serious accident. Monet writes Durand-Ruel on December 22 that the marriage of Germaine and Michel's accident have delayed his work.

1903

Water Lilies, No. 37
The Cloud, No. 38

Monet continues work on the Thames series from memory and progresses on the 1903–1908 Water Lilies series.

Pissarro dies.

1904

Water Lilies, No. 39

The trellis over the Japanese footbridge is completed.

May 9–June 4 Exhibition: thirty-seven of the Thames paintings are shown at the Durand-Ruel Gallery, Paris. These were made in London and Giverny over a period of more than four years. Many are sold by the gallery for 20,000 francs each. Octave Mirbeau writes the preface to the catalogue.

October Monet drives to Madrid with Alice for about a three-week stay to see, as he writes Durand-Ruel on October 4, the works of Velásquez.

Early December Monet visits London and attempts to arrange a Thames series exhibition there. He is unsuccessful.

1905

Water Lilies I, No. 40
Water Lilies, No. 41

Monet continues work on the 1903–1908 Water Lilies series.

Henri Matisse paints The Joy of Life (1905–1906).

January Monet continues work on a group of Thames views for possible exhibition in London.

February Exhibition: fifty-five paintings by Monet are included in the large Impressionist exhibition, sponsored by Durand-Ruel, at the Grafton Galleries in London.

November First photographs of Monet's garden are published in an article in *L'Art et les Artistes* by Louis Vauxcelles.

1906

Cézanne dies.

Pablo Picasso paints Les Demoiselles d'Avignon (1906–1907).

March 19–31 Exhibition: seventeen works by Monet from the Faure Collection are shown at the Durand-Ruel Gallery, Paris.

June 13 Monet writes Durand-Ruel that his work is not going well. Nonetheless he continues working on the Water Lilies series.

1907

Water Lilies, Nos. 42, 43
Water Lilies—Evening Effect, No. 44

Monet works almost exclusively on the Water Lilies series. On April 27 he writes Durand-Ruel that he is disheartened that the series will not be ready for exhibition this year. The work progresses very slowly.

Clemenceau arranges for Manet's Olympia to be transferred from the Palais du Luxembourg to the Louvre.

The state buys one of Monet's Rouen Cathedral paintings for the Palais du Luxembourg.

According to Lila Cabot Perry, an American visitor to Giverny, Monet has been burning and destroying canvases because he is worried about his reputation after death.

1908

Spring	Monet suffers from failing sight and occasional illness.
te September–December	Monet travels to Venice with Alice. He writes to Durand-Ruel on October 19 about his admiration for the city; the couple stays at the Palazzo Barbaro as the guests of Mr. Curtis, a friend of Sargent, and then at the Grand Hotel Britannia.
Winter	Monet works on the 1903–1908 Water Lilies series in his studio.

1909

January 28	Monet writes Durand-Ruel that his wife has been sick with what becomes a chronic illness.
May 6–June 5	Exhibition: Monet shows forty-eight paintings of his second series of Water Lilies (Nymphéas, paysages d'eau), painted between 1903 and 1908, at the Durand-Ruel Gallery, Paris. The larger water surface created by the 1901 excavations in the pond is visible in these works. Although comprised of different motifs, the entire group forms a harmonious unit.
Fall	Monet returns to Venice for his second visit.

1910

Alice's illness continues.

Monet begins new and final alterations to the water-lily pond, consisting in part of modifying the curvature of the banks.

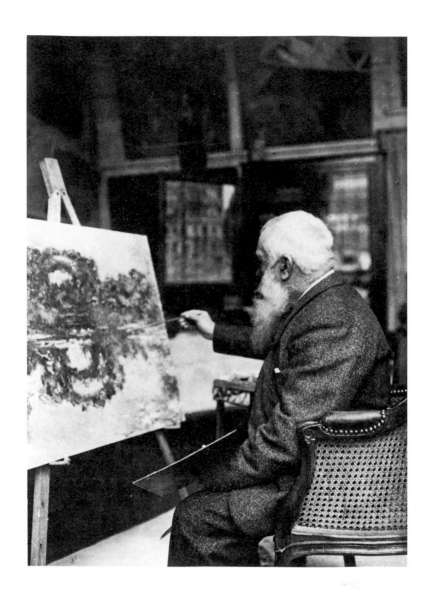

Monet in his studio finishing a painting from the Flowering Arches group, about 1913

From the archives of the Fondation Wildenstein, Paris

1911

May 19 Alice Hoschedé Monet dies. For Monet a long period of mourning and re-clusiveness begins.

Fall Monet apparently begins working again, from memory, on the Venetian paintings and on paintings of his water and flower gardens. He does not return to Venice to correct his studies.

1912

Winter-spring Monet finishes his Venetian canvases from memory.

May 28–June 8 Exhibition: Monet shows twenty-nine views of Venice at the Bernheim-Jeune Gallery, Paris. Octave Mirbeau writes the preface to the catalogue. This is the last time Monet exhibits a new group of his paintings, although his paintings are shown throughout the years in retrospective and group exhibitions.

July Monet visits an eye specialist in Paris who confirms the diagnosis of a doctor in Vernon of a double cataract condition.

1913

The Flowering Arches, No. 45

1914

Clemenceau and others encourage Monet to paint a group of large panels of the water-lily pond, a project that occupies him for the rest of his life. From this time on Monet devotes himself mainly to one project—a cycle of large Water Lilies, some of which are ultimately installed in the Orangerie in 1927. The idea of a permanent installation of these had been conceived by Monet as early as 1897. Critics and friends are aware from this time on of Monet's pre-occupation with this project. In June Félix Fénéon publishes a letter from Monet declining an invitation to the ceremonies in Paris for the Camondo Collection because he is totally involved in a large work ("grand travail"). Serious public discussion of the paintings does not begin until 1920.

169

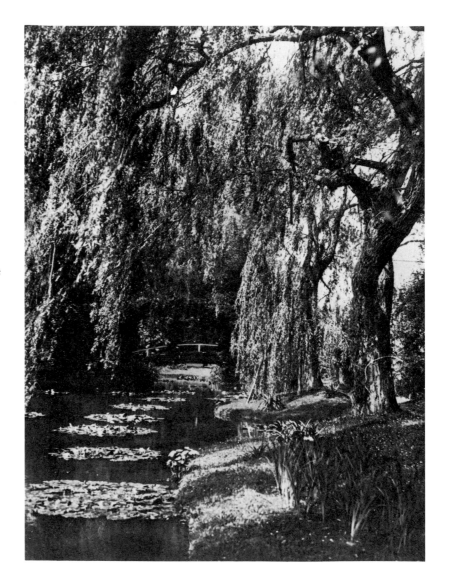

The pond, weeping willows, and the Japanese footbridge, 1924

Collection of Georges Truffaut

1914, continued

Monet begins construction of a third studio large enough to contain the oversize canvases necessary for his new Water Lilies cycle. Work continues on this building, while Monet continues painting the water-lily pond for the next two years. He is depressed and discouraged with his work.

February 10 Monet's son Jean dies after a lingering illness. Jean's widow, Blanche Hoschedé Monet, also Monet's stepdaughter, now becomes his housekeeper and close companion.

July France enters World War I.

1915

August 15 Monet writes his stepson Jean-Pierre Hoschedé that the third studio is ugly and that he is ashamed of it.

1916

Water Lilies (triptych) (1916–1923), No. 79

The third studio is completed, not entirely to Monet's satisfaction.

1917

Mirbeau, Rodin, and Degas die.

Summer Monet continues painting the water-lily pond and its surroundings.

Late October Monet takes a short trip to visit former painting sites, including Le Havre, Honfleur, Étretat, Yport, Pourville, and Dieppe.

1918

The Irises (1918–1925), No. 60
Irises (1918–1925), No. 61
Iris (1918–1925) No. 62
Irises by the Pond (1918–1925), No. 63
The Path through the Irises (1918–1925), No. 64

1918, continued

Flowers by the Pond (1918–1925), No. 65
Agapanthus (1918–1925), No. 66
Water Lilies (1918–1925), Nos. 68, 69
Water Lilies—Reflections of the Willow (1918–1925), No. 70

Monet continues to paint water-lily-pond subjects, including the wisteria over the Japanese footbridge and studies of specific flowers in his garden.

November 11 Armistice Day.

November 18 Clemenceau, now premier of France, and Geffroy visit Monet in Giverny to choose the Water Lilies for the state.

1919

Weeping Willow, No. 67
Water Lilies, No. 75
Water Lilies (triptych) (1919–1926), Nos. 76–78

Monet continues work on the water-garden motifs despite trouble with failing eyesight.

Renoir dies.

1920

The Roses, No. 59
Wisteria (diptych), No. 71
Wisteria, Nos. 72, 73
Water Lilies, Nos. 74, 81
Water Lilies (1920–1921), No. 80

October 9 Dealers Georges Bernheim and René Gimpel visit Monet in Giverny. Gimpel records in his diary that Monet wears glasses for reading and that they found his price of 30,000 francs too much to pay for a painting of ice floes.

October 15	Official announcement is made, in the *Chronique des Arts*, of Monet's plan to donate twelve large canvases of the water garden to the state. These are to be housed in a pavilion to be erected in the garden of the Hotel Biron (Rodin Museum), a plan that was later changed. Public discussion of these works by major critics begins.
November 14	The duc de Trévise interviews Monet on his eightieth birthday. Monet shows him panels of the large Water Lilies series and other motifs, such as the wisteria, in his third studio.

1921

Exhibition: a retrospective show, including some recent works, is held at the Bernheim-Jeune Gallery, Paris.

Depressed, Monet tries to withdraw his donation to the state. This angers Clemenceau, who has supported the project from its inception.

Monet continues painting in his gardens despite trouble with his eyes.

His painting Women in the Garden (Femmes au jardin), rejected by the Salon fifty-four years earlier, is purchased by the state for 200,000 francs.

1922

The Path with Rose Trellises, Giverny, Nos. 46–49
The House from the Rose Garden, Nos. 50–53

	Geffroy, now director of the Gobelins tapestry works, commissions for the state three tapestries based on paintings chosen by Monet.
April 12	At Clemenceau's request, Monet and Paul Léon (acting for the state) sign a notarized agreement at Vernon for the donation of the large panels of the Water Lilies to the state. These are to be installed in two specially constructed rooms in the Orangerie des Tuileries, recently annexed to the Louvre. The gift is to include nineteen panels—eight compositions, of one to four panels each—to be arranged in an oval or circle.

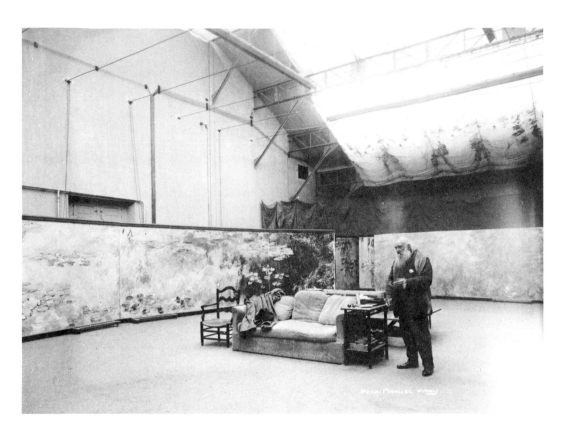

Monet in his third studio, surrounded by panels of his large Water Lilies series, 1920s
By Henri Manuel

Collection of the Musée Marmottan, Paris

The path with rose trellises, leading to the house
About 1926. By Nickolas Muray

The Museum of Modern Art, New York
Gift of Mrs. Nickolas Muray

1922, continued

Summer Although he continues painting, Monet experiences great difficulties with his vision. On September 10 he writes Durand-Ruel that his eyes are so bad that he has had to stop working and that his doctor in Paris recommends an operation.

Winter Monet works with the architect on the installation in the Orangerie.

1923

The Japanese Footbridge at Giverny, Nos. 54–57
The Bridge over the Water Lily Pond, No. 58

Winter Monet undergoes a cataract operation that partially restores sight in his right eye.

Summer He has another operation on his eyes, after which his vision is veiled and colors are distorted.

November His sight sufficiently restored, Monet resumes painting.

1924

Monet continues painting and reworking the Water Lilies.

Summer New eyeglasses are prescribed for Monet.

January Exhibition: a large retrospective show is held at the Georges Petit Gallery, Paris. The catalogue preface is written by Geffroy.

1925

Monet continues painting, although he is often depressed and discouraged and sees few people. He again tries to withdraw the panels destined for the Orangerie, angering Clemenceau, who writes him a stern letter. He refuses to part with the panels, although his "erratic behavior" endangers their existence. Despite trouble with his eyes, Monet has been reworking and destroying many of his pictures. He has burned many canvases he considers to be inferior.

By summer his sight seems to be improving.

1925, continued

June René Gimpel buys two canvases of women in boats from Monet for 200,000 francs each.

1926

Spring Geffroy dies.

Summer Monet can hardly see.

November Monet is too ill to leave his bed.

December 5 Monet dies; Clemenceau is at his side.

1927

May 17 Monet's Water Lilies are installed and dedicated in the Musée de l'Orangerie, Paris.

Claude Monet, about 1926. By Nickolas Muray

The Museum of Modern Art, New York
Gift of Mrs. Nickolas Muray

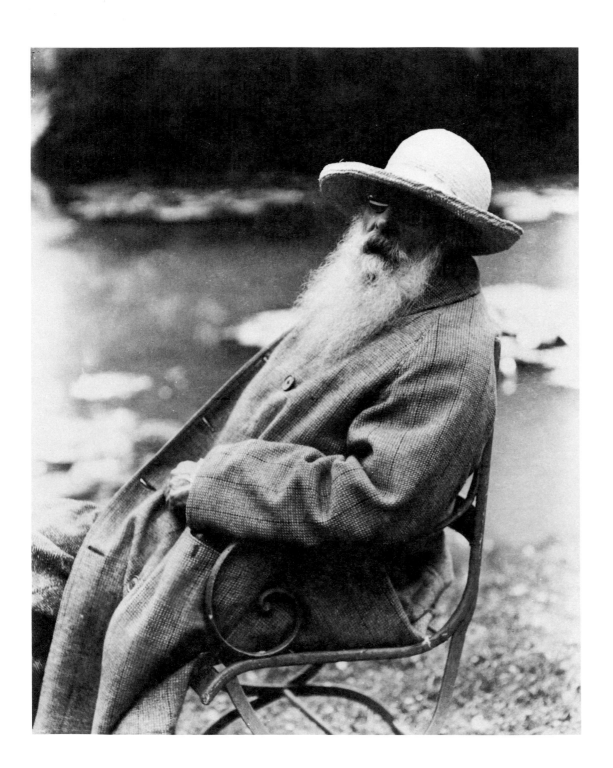

Selected Bibliography

Alexandre, Arsène. "Le Jardin de Monet." *Le Figaro*, August 9, 1901.

Anon. "Chez les peintres: Claude Monet—Albert Besnard." *Le Temps*, March 1, 1892.

————. "Der Garten Claude Monets in Giverny." *Werk* 39, June 1952 pp. 194–197.

Basel, Galerie Beyeler *Claude Monet, letzte Werke*, exhibition catalogue, 1962.

Blanche, Jacques-Émile. "Dans l'Atelier de Claude Monet." *L'Art Vivant* 3, January 1927, pp. 9–10.

————. "En me promenant aux Tuileries: Les 'Nymphéas' de Claude Monet." *L'Art Vivant* 3, September 1927, pp. 695–696.

Boston, Museum of Fine Arts. *Monet Unveiled*, exhibition catalogue, 1977.

Breuil, Félix. "Les Iris aux bords des eaux." *Jardinage* 21, October 1913.

Byvanck, Willem G. C. *Un Hollandais à Paris en 1891: Sensations de littérature et d'art*. Paris: 1892.

Chicago, Art Institute of Chicago, *Paintings by Monet*, exhibition catalogue, 1975.

Clemenceau, Georges. *Claude Monet: Cinquante Ans d'amitié* (original title: *Claude Monet: Les Nymphéas*). Paris: 1928 (trans. George Boas, New York: 1930). (Reprint, Paris and Geneva: 1965.)

Cooper, D. "Monets in the Metropolitan Museum." *Metropolitan Museum Journal* 3, 1970, pp. 281–305.

Coplans, John. *Serial Imagery*, exhibition catalogue. Pasadena: Pasadena Art Museum, 1968.

Daulte, F. "Monet pour le Musée Marmottan." *Connaissance des Arts* 232, June 1971, pp. 100–105, 151–157.

de Maupassant, Guy. "La Vie d'un paysagiste." *Gil Blas*, September 28, 1886.

Elder, Marc. *À Giverny, chez Claude Monet*. Paris: 1924.

Elderfield, J. "Monet's Series." *Art International* 18, November 1974, pp. 28–29, 45–46.

Fels, Marthe de. *La Vie de Claude Monet*. Vies des Hommes Illustrées 33. Paris: 1929.

Francis, H. S. "Claude Monet, Water Lilies." *Cleveland Museum Bulletin* 47, October 1960, pp. 192–198.

Gassier, P. "Monet et Rodin photographiés chez eux en couleur." *Connaissance des Arts* 278, April 1975, pp. 92–97.

Geffroy, Gustave. "Claude Monet." *Le Journal*, June 7, 1898 (reprint: *Le Gaulois*, June 16, 1898 [supplement]).

————. *Claude Monet, sa vie, son temps, son oeuvre*. Paris: 1922.

Gimpel, René. "At Giverny with Claude Monet." *Art in America* 15, 1926–1927, pp. 168–174.

————. *Journal d'un collectionneur, marchand de tableaux*. Paris: 1963 (trans. John Rosenberg, New York: 1966).

Giolkowska, Muriel. "Monet—His Garden, His World." *International Studio* 76, February 1923, pp. 371–378.

Goldwater, Robert. "Symbolic Form: Symbolic Content." *Acts of the Twentieth International Congress of the History of Art* IV. *Problems of the 19th and 20th Centuries*. Princeton: 1963, pp. 111–121.

Gordon, Robert. "The Lily Pond at Giverny: The Changing Inspiration of Monet." *Connoisseur* 184, November 1973, pp. 154–165.

Gordon, Robert, and Joyes, Claire L. "Claude Monet in Giverny." *Du*, December 1973, pp. 872–893.

Greenberg, Clement. "The Later Monet." *Art News Annual* 26, 1957, pp. 132–148, 194–196 (reprint: *Art and Culture*, Boston: 1965, pp. 37–45).

Guillemot, Maurice. "Claude Monet." *La Revue Illustrée* 13, March 15, 1898.

Gwynn, Stephen. "In Monet's Country I—Vétheuil and Vernon." *Country Life*, December 17, 1932, pp. 686–687.

————. "In Monet's Country II—Claude Monet's Garden." *Country Life*, December 31, 1932, pp. 740–741.

————. "Claude Monet's Lily Garden." *Country Life*, October 7, 1933, pp. 355–358.

————. *Claude Monet and His Garden*. London: 1934; New York: 1935.

Hamilton, George H. *Claude Monet's Pictures of Rouen Cathedral*. London: 1960.

Hoschedé, Jean-Pierre. *Claude Monet, Ce Mal Connu*. 2 vols. Geneva: 1960.

Howard-Johnston, Paulette. "Une Visite à Giverny en 1924." *L'Oeil* 171, March 1969, pp. 28–33, 76.

Janin, C. Review of Monet's Poplars exhibition. *L'Estafette* (Paris), March 10, 1892.

Jean-Aubry, G. "Une Visite à Giverny." *Havre Eclair* (Le Havre), August 1, 1911.

Joyes, Claire. *Monet at Giverny*. New York: 1976.

Kahn, Maurice. "Le Jardin de Claude Monet." *Le Temps*, June 7, 1904.

Levine, Steven Z. *Monet and His Critics*. New York and London, 1976.

————. "Monet's Pairs." *Arts Magazine* 49, June 1975, pp. 72–75.

————. "Decor / Decorative / Decoration in Claude Monet's Art in Acquavella Gallery Exhibition." *Arts Magazine* 51, February 1977, pp. 136–139.

London, Arts Council of Great Britain, *Claude Monet*, exhibition catalogue, 1957.

Marx, Roger. "Les 'Nymphéas' de M. Claude Monet." *La Gazette des Beaux-Arts*, ser. 4, 1, 1909, pp. 523–531.

Mirbeau, Octave. *Exposition Claude Monet—Auguste Rodin: Galerie Georges Petit*. Paris: 1889.

——. "Claude Monet." *L'Art dans les Deux Mondes*, March 7, 1891.

——. "Lettres à Claude Monet." *Les Cahiers d'Aujourd'hui* 5, November 29, 1922, pp. 161–176.

Mount, Charles M. *Monet: A Biography*. New York: 1966.

Paris, Musée Marmottan. *Monet et ses Amis, le legs Michel Monet, la donation Donop de Monchy*, 1977.

Perry, Lila Cabot. "Reminiscences of Claude Monet from 1889 to 1909." *The American Magazine of Art* 3, XVIII, March 1927, pp. 119–125.

Rewald, John. *The History of Impressionism*. 4th rev. ed. New York: 1973.

——. *Post-Impressionism: From Van Gogh to Gauguin*. 2nd. ed. New York: 1962.

Rouart, Denis. *Claude Monet*. Geneva: 1958.

Rouart, Denis, and Rey, Jean-Dominique. *Monet: Nymphéas: Ou Les Miroirs du temps*. Paris: 1972.

St. Louis City Art Museum and Minneapolis Institute of Arts. *Claude Monet*, exhibition catalogue, 1957. Essay by William C. Seitz.

Seiberling, Grace. "Monet's Series." Ph.D. dissertation, Yale University, New Haven, Connecticut, 1976.

Seitz, William C. "Monet and Abstract Painting." *College Art Journal* 1, XVI, 1956, pp. 34–46.

——. *Claude Monet*. New York: 1960.

——. *Claude Monet: Seasons and Moments*, exhibition catalogue. New York: Museum of Modern Art, 1960.

——. "The Relevance of Impressionism." *Art News* 67, January 1969, pp. 29–34, 43, 56–60.

Sloane, J. C. "Paradoxes of Monet Paintings in the Musée Marmottan." *Apollo* 103, June 1976, pp. 494–501.

Trévise, duc de. "Le Pèlerinage de Giverny." *La Revue de l'Art Ancien et Moderne* (special edition) 51, January–February 1927, pp. 42–50, 121–134.

Truffaut, Georges. "Le Jardin de Claude Monet." *Jardinage* 87, November 1924.

Vaudoyer, Jean-Louis. "Claude Monet. . . ." *La Chronique des Arts et de la Curiosité*, May 15, 1909, p. 159.

Vauxcelles, Louis. "Un Aprés-midi chez Claude Monet." *L'Art et les Artistes* 2, November 1905, pp. 85–90.

Venturi, Lionello. *Les Archives de l'impressionnisme*. Paris and New York: 1939.

Wildenstein, Daniel. *Claude Monet, biographie et catalogue raisonné*, I. Paris: 1974.

Monet four months before his death, 1926. By Nickolas Muray

The Museum of Modern Art, New York
Gift of Mrs. Nickolas Muray

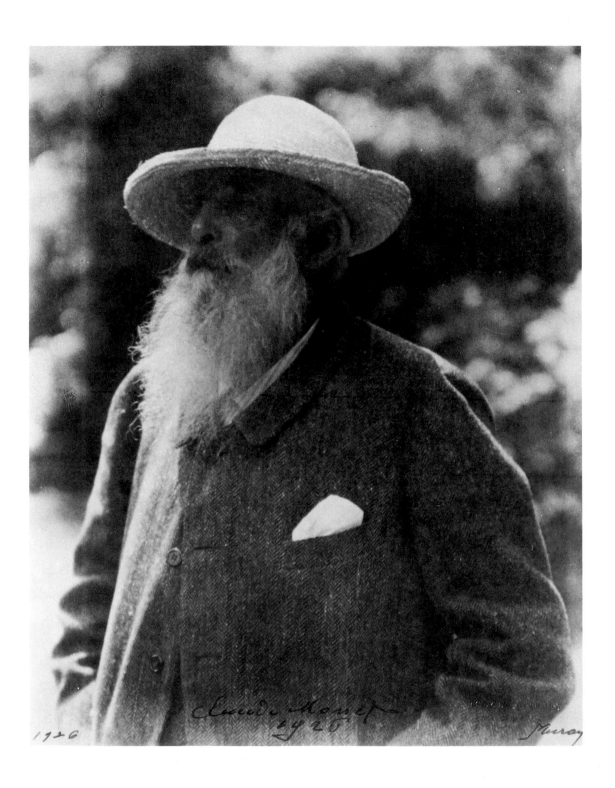

Claude Monet
1926

1926 Murray

Edited by Polly Cone / Designed by Peter Oldenburg / Map prepared by MM. Walter and Grelaud, Fondation Wildenstein, Paris. Redrawn by Joseph P. Ascherl / Mechanicals and supplementary graphics by Barbara J. Zapatka / Printed and bound in Japan

Fourth printing, 1979 : 35,000 copies